VOICES OF AMERICA

VOICES OF
Barrington

Come Join Us

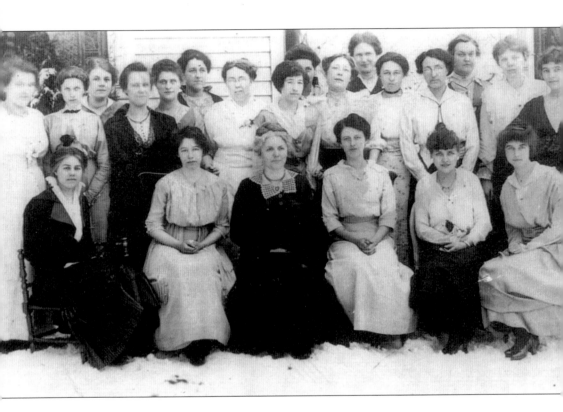

Ladies Auxiliary of
Barrington's
Salem Baptist Church

(Photo courtesy of Community Church of Barrington.)

VOICES OF AMERICA

VOICES OF
Barrington

Diane P. Kostick

ARCADIA

Published by Arcadia Publishing,
an imprint of Tempus Publishing, Inc.
3047 N. Lincoln Ave., Suite 410
Chicago, IL 60657

Printed in Great Britain.

Library of Congress Catalog Card Number: 2002104296

For all general information contact Arcadia Publishing at:
Telephone 843-853-2070
Fax 843-853-0044
E-Mail sales@arcadiapublishing.com

For customer service and orders:
Toll-Free 1-888-313-2665

Visit us on the internet at http://www.arcadiapublishing.com

The Barrington area lies 35 miles northwest of Chicago just beyond the urbanized fringe. The Village is the focal point, offering its citizens and the people of the surrounding areas over 200 stores in which to shop, do business, eat, or just gather to chat. Barrington is also horse country with wide open spaces, rolling hills, rippling lakes, and verdant pastures. It is a town that works and a community that guards against city sprawl. It has a healthy and diversified economy that manages to balance light manufacturing and research facilities. Today, it is recognized as one of the most attractive suburban communities in which to live and rear a family, and residents appreciate that it is in close proximity to the splendor of the Windy City.

Contents

Barrington Area Map

The Barrington area straddles six townships and covers ninety square miles. It is situated along the Northwest Tollway and Fox River Valley. It is crisscrossed by the U.P. and E.J.&E. railroads and bisected by several major roadways. Peat bogs, marshlands, and lakes of the region welcome countless species of wildlife during the spring and summer seasons.

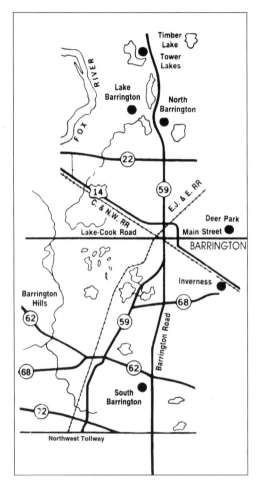

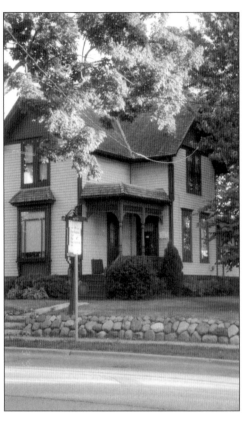

Handsomely restored, the Kincaid-Donlea house graces Lake-Cook Road adjacent to Barrington's downtown district. The house was originally built in 1898. Today, tall trees of the era still shelter the house and grounds. Now the picturesque home serves as headquarters for the Barrington Historical Society and BACOG (Barrington Area Council of Governments).

Acknowledgments

I wish to thank the following individuals and organizations for their time, efforts, and materials which aided in the production of this book:

Barrington Area Arts Council
Barrington Area Library Staff
Barrington Writers Workshop
Barrington Fire and Police Departments
Barrington Middle School-Station Campus
Anne Branstrator
Community Church of Barrington
Joanne Fitzgerald-Rose Packing Co.
Abraham Garcia
Lake County Discovery Museum
Miriam Lykke

Barrington Area Arts Council is now at home on Park Avenue just adjacent to the Union Pacific (U.P.) Railroad. BAAC has been a vital agent for arts promotion. In 2002, it celebrates its 25th anniversary. Sarah R. Bowers is the current Executive Director.

Introduction

Voices of Barrington is a series of interviews conducted over a 3-year period. The men and women profiled are linked by their willingness to face adversity, to struggle and overcome personal hardships, or to fail and then succeed. Along the way, each found time to help others. Their stories represent voices from the distant past, as well as sounds of the here and now. Their profiles cover a wide span of ages, talents, and personalities. They include a barber, self-made businessman, a woman who is helping change lives in remote villages of the world, a world class sportsman and photographer, a world-renowned science fiction writer, and a beloved local vet.

A common thread runs through their lives: they are visionary people who possess the strength to make their dreams come true. *Voices of Barrington* seeks to honor its citizens, not laud its barns, buildings, historic structures, or lush countryside. The collected stories form a kaleidoscope of color and character and portray the commitment of these individuals to their families, friends, and community.

Collectively, these men and women align to speak of the rich history of the area. Forging their individual efforts has helped create the splendid environment residents have come to appreciate. Their stories prove Barrington to be a truly typical American village.

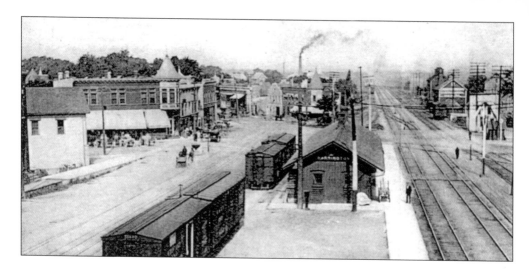

The expansion of the railroad from Chicago to Barrington and on to Cary invited many businesses and families into the Barrington area. However, today's village population remains at just over 10,000. This view is looking northwest along the tracks towards Cary. At the turn of the century, the depot was located on the south side of the main tracks. In the left center of the picture, a horse team is about to reach the watering trough in the center of Railroad Street. This bird's-eye view represents Barrington's downtown commercial center at that time. Several buildings in the photo were later moved to other lots in the area. For example, the Sodt Brothers General Store was wheeled over to the corner of Cook and Station streets and became the Town Shoppe. (Photo courtesy of Lake County Museum.)

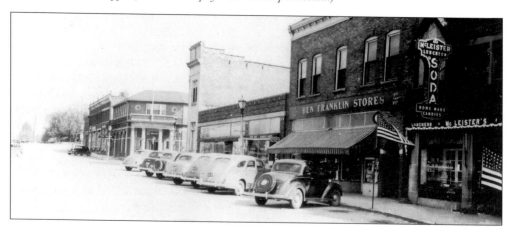

Barrington's downtown business district featured Lipofsky's Department Store (around the right corner), the Ben Franklin Five-and-Dime Store, and McLeister's sweets-emporium, established in 1913. The shop offered the best homemade candies and soda-fountain creations in the area. By the time this photo was taken, cars had replaced horse-drawn carriages, and paved streets and sidewalks had replaced wooden sidewalks. Prior to that time, during the dry season, the dirt roads had to be sprinkled with water to prevent clouds of dirt from covering every inch of nearby homes and businesses. By 1922, Dundee Avenue and Main Street to Northwest Highway were the first roadways to be paved. The rest of the village streets were concrete-covered between 1927 and 1928, making trips to shop in town much more pleasurable. (Photo courtesy of Lake County Museum.)

History of Barrington

Early records show that after the Blackhawk War of 1832, a treaty was signed on September 26, 1833, at a powwow held on Ela Flat in Deer Grove. The opposing parties reached an agreement which stated that the Native American Potawatomi, Chippewa, and Ottawa Indians would cede their lands along the western shore of Lake Michigan to the United States government. They had to move west of the Mississippi no later than 1836, and the tribes were to be given $100,000 in annuities and grants.

Their spirits bolstered by the terms of the treaty, white settlers began to arrive in the Barrington area in 1834. Among the earliest arrivals were Jesse F. Miller, Benjamin Irick, Henry Clawson, A.C. Bucklin, E.N. Miller, Jesse M. Miller, Benjamin Richardson, Gilbert A. Applebee, William H. Otis, Homer Willmarth, L.O.E. Manning, George S. Browning, Henry Smith, William Freeman, and Alvah Miller. Some of these men came alone; others brought their families in covered wagons on a journey that took months. They found the surrounding area to be three-fourths prairie and one-fourth woods. The pioneers were lured by the promise of reasonably priced parcels of land, plentiful water, and fertile soil. Most of these settlers were English, German, or Irish. They were hardy, industrious people who came to put down roots, clear the land, plant crops, raise livestock, and produce large, strong families.

By the early 1840s, numerous log cabins peppered the village and surrounding land. In 1850, the county sheriff came through and posted notices that the inhabitants should assemble and select a name for the township and should develop a plan for organizing a government. A meeting was held at the home of William Otis, east of Miller's Grove, and the name chosen for the community was Barrington because so many of the people had come from an area near Greater Barrington, Massachusetts. By 1863, the necessary terms to create a municipality had been written, and on February 16, 1865, the Illinois legislature granted Barrington a charter.

While Barrington was forming a governmental base, it was changing radically along with the development and construction of the Illinois and Wisconsin Railroad. By 1854, tracks

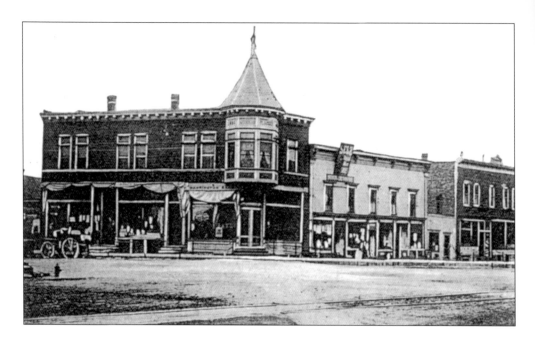

Bank Corner, pictured here in downtown Barrington, Illinois, c. 1913. The first bank in town was built in the west end of the community in early November, 1889. The First State Bank was established in 1913, headed by President John Robertson. John C. Plagge served as the bank's Vice President. Both men owned hundreds of acres of land in and around the village. (Photo courtesy of the Lake County Museum.)

were laid as far west as Deer Grove and as far north as Cary. Robert C. Campbell, a civil engineer for the railroad, was commissioned to lay out plans for house sites because homes would be needed for employees when the rail lines were fully operational. Using the English measurement system of chains and links, Campbell outlined new lot-lines within an 8-acre boundary. The area became the nucleus of Barrington proper. As service on the railroad grew, so did Barrington. By 1889, the Elgin, Joliet & Eastern Railroad also laid tracks, further contributing to the growth of the community.

The railroad brought a steady flow of new arrivals who were delighted to be living outside congested urban areas and in a more intimate community. Pioneer businesses grew up near the railroad to serve the increasing numbers of farm families, as well as the business families in the town. The post office was moved from a home on the outskirts of the village and reestablished itself near the train station. People from nearby communities moved into Barrington to be near the railroad station and the stores that were opening to serve their needs.

When Tom Creet first came to the area, he erected a blacksmith shop, which stood at the southeast corner of Baldwin and Schaumburg Roads. The Creet home, their household goods, and the blacksmith shop were moved to Barrington from south of the village on a flatbed rail car. Creet's house and shop were set down at the corner of Cook and Station Streets where passing children gathered to watch men forge red-hot metal and pound horse shoes, and to listen to the bellows roar.

By the end of the century, Barrington was a bustling town. It boasted a hardware store, drug store, jewelry and watch repair shop, a livery stable, post office, general merchandise

store, undertaker parlor, and saloon. In wet weather, the center of town was a sea of mud. Crosswalks provided residents with protection from the elements, but the sticky mud rose and covered the wooden passage-ways. Cement sidewalks were not poured until 1907.

The biggest fear of the early residents was fire. Homes were lit by tallow candles or by open fireplaces. Cooking was done in the fireplace or on a wood stove. Iron kettles hung from movable rods that swung over the fire, or baked in an oven that was nothing more than a hole in the wall. There was no firefighting equipment in the village. Water was available only from a nearby stream or small well. Fires had to burn themselves out unless a bucket brigade could be formed quickly. Most home fires were a total loss, and fires along the business street were a disaster. In 1890, a major fire erupted in downtown Barrington, killed one man, and destroyed an entire block of buildings. In 1898, a horrific blaze swept east along the railroad track, consuming a second block. The townsfolk took action.

A fire department was established on June 15, 1898, and 37 volunteers joined. They agreed to drill a well and erect a standpipe on top of the hill at Hillside and Hough Streets. Water mains, hydrants, and a reservoir were installed in back of city hall. Barrington's first piece of fire equipment was purchased. The rig carried about 50 yards of hose and 2 brass nozzles. Edward J. Heise was the organizing president and John Frommelkamp was the first fire marshal. With the clang of the Zion Church, firemen sprang into action for weekly drills held on Main Street. If fire broke out, whistles on top of the Bowman Dairy and Gieske's Steam Laundry sounded the alarm.

Construction of schools and churches paralleled the growth of the community, and by

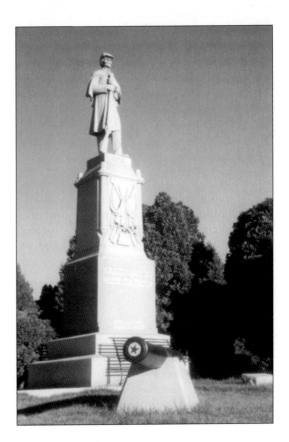

Evergreen Cemetery was established in 1816, and a charter was granted in 1869. When the original five acres were purchased, the land was plowed and planted with oats until the grass and lots were sold. This Civil War soldier stands guard over the grounds and commemorates Barrington soldiers who died during the nation's conflict.

the 1840s, the one-room school house called Northway School was serving local children. The second school was built on South Hough Street in 1855, and served students of all ages. The first church settlements included the Methodists, Baptists, St. Paul's Evangelical, Zion Evangelical, and St. Anne's Roman Catholic.

In 1898, the telephone company installed poles and lines in Barrington and started with 20 subscribers. The same year, an electric generating plant was built at the end of Harrison Street. Strings of lights were draped across the streets at each intersection about a block apart. The electricity was shut off at 11 p.m. and not turned on again until dawn.

As Barrington's population increased, so too did the number of businesses and industries. The American Malleable Iron Works was constructed in 1898, but went bankrupt by 1900 due to inferior castings. A village hall was built on Hough Street in 1899, and by the 1900s, citizens enjoyed motion pictures shown on the second floor. The Barrington Steam Laundry opened in 1900 and enjoyed immediate success. Around this time, the First State Bank of Barrington was also established. It took up residence at the corner of Cook Street and Park Avenue.

In 1929, Barrington established a police chief position and bought its first squad car. Ernst W. Baade served as chief from 1929 to 1950. The police department purchased its

According to Barrington's historian Arnett C. Lines, "The earliest police that we remember were 'Hank' Sandman and John C. Meyers; the former was called the Marshal of the Day and the latter was the Night Watchman. It is believed that before them the peace officer was the constable." The photo above shows the Barrington Police Chief at a Park Picnic, c. 1940s. (Photo courtesy of Barrington Fire Department.)

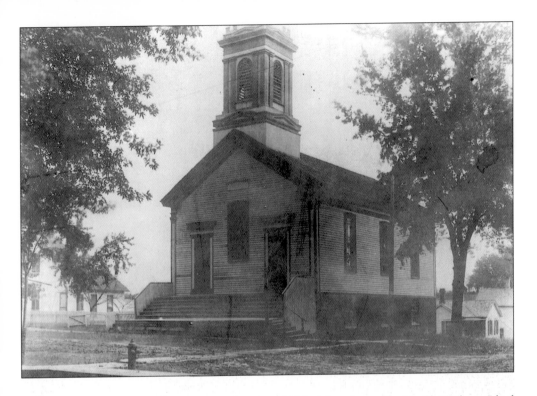

The Baptists organized as a church by 1847. The group of 20 had formerly worshiped in the Northway School near Penny Road. When the railroad came to Barrington in 1854, church members began thinking of moving the congregation into the village. The original parsonage was the house just east of the church. A building 35 feet by 50 feet was erected in 1859 for the tidy sum of $2,222. The photo shows the Baptist Church, which was located at the corner of Lincoln and Grove Avenues. (Photo courtesy of Community Church of Barrington.)

first two-way radio system in 1948. The police department was located on the second floor of the village hall until in 1951, when the community deemed it needed more space.

As the community developed, so did the need to lend and borrow books. William J. Cammeron offered a section of his drug store for a library. Under the urging of the Barrington Women's Club, the library was moved to a room on Cook Street over George Wagner's market. Members of the Women's Club served as librarians and by 1926, a Library Board was elected. Books continued to circulate in and out of the village hall until 1957, when the library moved to a new home up the street. Later, it moved to a building on Hough and Monument Streets.

Barrington celebrated its bicentennial in 1963. A year-long program of activities was planned for the village. Most events took place during the week of July 3–10 during which time historical walking tours, lectures, and displays were featured. The town held parades, picnics, and beard-growing contests. The sixties also brought Senator John F. Kennedy to Barrington to seek support in his bid for the Oval Office. His entourage was greeted at Barrington High School by loyal Democrats carrying colorful banners. Curious Republicans who couldn't believe that Kennedy could actually become our 35th and youngest president came, too. "Kennedy was the talk of the town," said local barber, Ray Tourville.

In 1968, the Barrington Historical Society was established to collect and house local

memorabilia, including items saved when Hough Street School fell to the wrecking-ball. Barrington now boasted an impressive, innovative middle school which offered local sixth, seventh, and eighth grade students "a taste of true exploration without the pressures of being housed with high schoolers," declared then Superintendent Robert Finley.

The seventies brought a decade of efforts to preserve the countryside and improve the lifestyle in Barrington. To that end, BACOG (Barrington Area Council of Governments) was formed to serve as a planning tool for the protection of land and the environment, and control of housing development, as well as transportation in the area. BACOG was instrumental in preventing several developments and unsightly growth. In 1974, proponents of a local hospital began an earnest search for property and a hospital association to satisfy residents' needs. In 1976, their efforts led to breaking ground for Good Shepherd Hospital off Kelsey Road near Route 22. The dedication took place on September 23, 1979.

Environmental concerns dominated the eighties. Road congestion through the downtown area remained a sore spot with politicians and concerned citizens. In March, Cuba Township officials agreed to create an open space district of more than 700 acres and prepared a referendum question for the upcoming November ballot. During that time, Barrington also announced plans to begin recycling plastics.

The ever-expanding Barrington Park District agreed to seek bids on an 18-hole miniature golf course tentatively planned for Langendorf Park. Charlotte's, the most famous local pub, closed its doors in order to widen Route 14, and the unofficial town historian and life-time resident, Bill Klingenberg, died at age 85.

The late-eighties witnessed a 7% jump in retail sales in Barrington. Lipofsky's Department Store was destroyed by fire a week before Christmas in 1989. Barrington area voters approved a $10.8 million bond referendum to build a new middle school and agreed to $5.3 million for a library addition. Meanwhile, lines were drawn between two opposing education-tax watch-dog groups: Barrington Enlightened Taxpayers (BETA) and Taxpayers for Excellence in Education (TEE). Growth and development continued in the area. Bockwinkle, an upscale food market, opened in the recently opened Foundry. The Park District announced plans to convert part of a maintenance garage to classrooms, and construction began on Ron Beese Park.

Barrington concerns continue to ebb and flow—redevelopment of the downtown area, traffic congestion, a second commuter train line, increased taxes for schools and library, preservation of open land versus development, and increased demands for public service persist. However, Barrington remains a great suburban community in which to raise a family, live, or run a business.

II .

Lola Rieke

Lola Rieke is a grand dame of Barrington and not for one second does she consider herself to be held in such high regard in the community where she was born and raised. Lola is especially held in high esteem by those who know, love, and respect this robust, intelligent, witty nonagenarian.

"I secretly wish I could have become a math teacher, but I became a secretary after graduating from Northwestern University in 1929," said a diminutive Lola Rieke, as we begin our interview. Around the room of her cozy ranch house, there are pictures of family and friends resting on end-tables, book shelves, and dresser tops. Her mahogany piano sits near the door and speaks of Lola's second passion: music. A book of hymns rests open at the ready for her knuckle-swollen fingers. "I attend the Elgin Symphony with friends, and I played the cello in college," Lola said.

She is a determined, white-haired, soft-spoken woman whose almost wrinkleless face gives no hint of her long life. She was the second child born to Fred and Edith Hager Rieke on Tuesday, November 5, 1907. A brother Foster preceded her by two years; a brother, Jim, was born in 1924; and a sister, Jean , followed in 1929.

"We were really two separate families. When new babies came along, no one talked about their impending births. Seems like the children just showed up one day and were accepted into the family. At the time, we lived on Dundee Avenue. My brother Foster was the brains of the family. He graduated from Harvard University, and became a physicist and a pioneer in the development of the microwave oven. Foster worked on several highly-secret projects for the University of Chicago, maybe even the Manhattan Project, and he worked for one of the local research labs. I'm not exactly sure what he was involved in, but it wasn't something he was able to talk about freely. Foster died in 1970, a giant in the field of physics.

Dad was a postal worker and rode horseback into Barrington's countryside to deliver mail. He was glad when he and his younger brother Ruben bought the well-drilling business from their older brother Raymond. He was now liberated from his daily rural mail

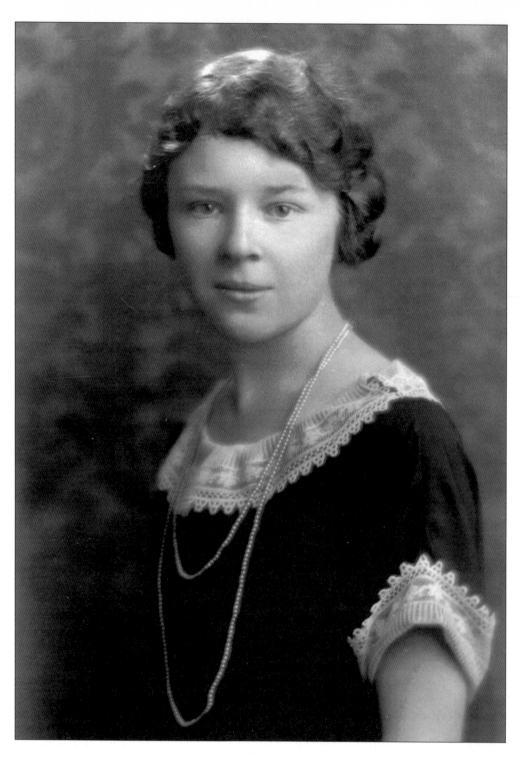

Lola settles into a serene pose for her graduation portrait from Northwestern University in 1929. (Photo courtesy of Lola Rieke.)

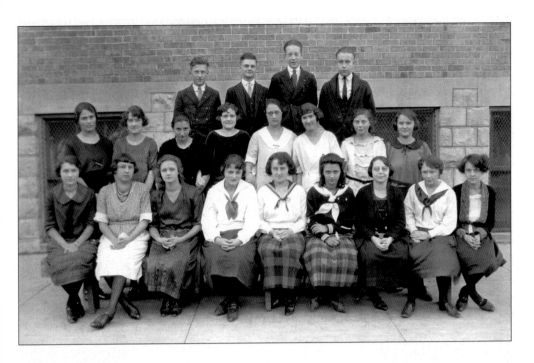

On November 5, 1883, a contract was signed to erect new wings for Hough Street School on or before September 1, 1883, at a cost of $3,700. In 1946, it was deemed necessary to construct a separate high school. On September 12, 1949, classes began in the new building. The photo is from the Class of 1922. Students include the following: Fred Beinhoff, Isabelle M. Kincaid, Zoa Jayne, Alice Wienecke, Millard Gieske, Justine S., Alice Baecher, Lucille Kirschow, Johanna Gesdau, Francis Magill, Ema Garbisch, Lola Rieke, Mrs. Gieske, and Lucille S. (Photo courtesy of Lola Rieke.)

route. Dad preferred being one of the bosses, being able to set his own schedule, and make his own decisions. He usually left the house at 7 a.m. and worked until dark. His new venture enabled him to purchase a truck, one of the first in the area, and he was quite proud buzzing around the community in his new Ford pickup. Even during the Depression, Dad continued to drill wells, although the number he dug was cut back rather dramatically. I remember that we tightened our belts during the thirties, but I don't remember the devastation Steinbeck recalls of the Oakies in *The Grapes of Wrath*.

Mom was a homemaker, typical of women of her era. She followed a daily routine of cooking, cleaning, and caring for her extended family. I remember watching her bake breads, pies, and cookies. She also canned apples, cherries, peaches, carrots, beets, and tomatoes. We had several fruit trees and a large sun-splashed garden in the back yard, providing Mom with a bountiful harvest. She lined basement shelves with colorful Mason-filled jars, and we had an abundance of fruits and vegetables all winter long. Like most people in Barrington, Mom even raised chickens. Meals were the basic, meat-and-potato variety, and they were always hearty, fresh, and filling.

Mom was a hard worker. I watched her pump water into the kitchen sink from the cistern in the basement. At the time, we had only cold water, and Mom used our coal burning stove to heat every drop she used for cooking, bathing, and Monday morning laundry."

The Rieke house was lit by kerosene lamps. "I can still recall its pungent fumes which clung to our draperies, furniture, and clothes. I woefully remember one time, after I won a ribbon in a three-legged race at school, my brother Foster set the ribbon on top of the kerosene chimney. It caught fire, and I was furious with him and afterwards I didn't speak to him for several days.

My Uncle Raymond and my aunts, Gertrude and Luella Hager, boarded with us. Every night we had a host of people around the dinner table and their talk was endless and stimulating. I learned a lot by being a good listener. I have always been endlessly curious. Because my aunts and uncle lived with us, my parents managed to get by when money was tight. I think each of them paid my parents about $3–$4 per week, enough to make ends meet.

Sometimes, my mom worked for Dr. Richardson, a local doctor. She'd help his family with simple household duties and care for his children, but she wasn't away from home often. The money she earned supplemented what my dad earned. My parents were quite frugal."

Baker's Lake, which is located south of Northwest Highway between Ela Road and Route 59, is a haven for threatened species of birds. The center island is merely 30 yards long and 10 yards wide, but it serves as a sanctuary for northern Illinois birds to nest and reproduce. It is home to Great Blue Herons, Double-crested Cormorants, Snowy Egrets and various species of ducks. The area is dedicated as a state nature preserve, so the 209 acres of lake, island, and shoreline are protected against sale or use for any other purpose.

Growing up in Barrington was exciting, according to Lola. She fondly remembers her childhood as being delightful and happy. She started school in 1913, and attended Hough Street School until she graduated from high school in 1924. In those years, Hough Street School served students from kindergarten through high school. It was a solid, red brick building with a large, dark wooden—and thus noisy—central hallway that led into a winding stairway. A smooth set of parallel banisters flanked the wide staircase that led to the second and third floors. Boys sometimes used the banisters to make a hasty exit at the end of the day when the bell rang and no one was looking.

"Life was simpler then. School lessons were basic. We had classes in arithmetic, reading, spelling, history, geography, and penmanship. My favorite subject was math. I didn't care much for geography or history, and I don't know why because I like to travel and learn about other cultures. I even worked for a business that specialized in map making, so it would seem that I did have a subconscious interest in geography.

My best school times were when I was in the seventh and eighth grades. I remember we girls took a liking to the boys, and the boys took a liking to us. But, by the end of eighth grade, most of the boys had quit school and went to work on their family farms. In fact, there were only about four boys in my high school graduating class. Perhaps that's why I never dated much or married. Boys were not readily available in most social situations.

Outside of school, my aunts, Gertrude and Luella, had a profound effect on my life. My parents went to church only for meetings or on holy days, but my aunts, who taught Sunday school, took me to church with them. Every week they took me to Sunday school housed in what is now the Masonic Lodge. Boys attended classes in one room, girls in another. Times sure have changed.

In 1925, when I was 16 years old, I was baptized. Reverend Jon DeLong was Pastor and he and his wife played a large role in the church. I liked both of them very much. They were well-educated and very talented people and meant a lot to the members of Barrington United Methodist Church. I still have fond memories of both.

My social life centered around picnics, buggy rides, and ice cream socials. We would drive to the forest preserves and spend the day having a grand time playing group games and feasting on homemade treats spread out on thick woolen blankets. We usually stayed out until nightfall.

Dancing was discouraged, probably prohibited. One Friday evening during a school get-together, a young man was sitting in the gym at the piano. He started playing and school district Superintendent Smith walked up to him, put his hand on the young man's shoulder to indicate that the music that he was playing was unacceptable in our school setting. Displeased with the superintendent's apparent sanction, the piano player stood up and began beating Dr. Smith about the head. After that the superintendent spent several days explaining to a curious community why he had a badly-bruised and swollen face.

Conservatives ran our churches and school board; they were powerfully instrumental in establishing the social and ethical policies in our community. They established the moral climate which we followed or we were ostracized. In addition, every adult in the community had an undeclared right from all parents to discipline any child seen misbehaving.

Besides my aunts, the person who was my best role model was Mr. Falkenstein, my high school math teacher. He was the one who encouraged me to continue my education. He got me a part-time job working for Nystrom, Chicago's famous cartography company. With Mr. Falkenstein's urging, I decided to go to Northwestern University. My uncle was finishing graduate school at NU, and he knew he would keep watch over me.

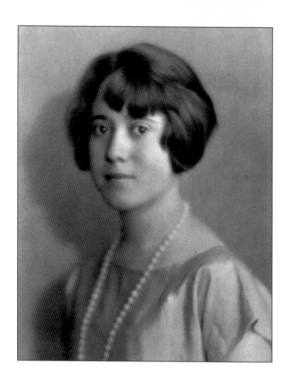

Eleanor "Boothie" Booth, Lola's friend and roommate during her days at Northwestern University. (Photo courtesy of Lola Rieke.)

When I signed up at Northwestern, I had no idea what I wanted to study. If I could go back to that time, I know I would have become a math teacher or a CPA. Northwestern didn't have any teacher training programs, and I would have had to attend Northern Illinois for that kind of training. So I elected to take a liberal arts course of study.

I borrowed money from my aunts and later from my Grandfather Rieke to continue going to school. Like most women living on campus in Chapen Hall, we cut expenses by working for our room and board. We cleaned the hallways, set and cleared the dining room tables, and washed the dishes and silverware after each meal.

My fondest Northwestern memory is of my roommate, Eleanor Booth. I nicknamed her 'Boothie.' She was so different from anyone I knew in Barrington. I was thunderstruck by her; she was exotic. Boothie's family lived in China where her father was a missionary and an administrative assistant at one of the local Christian schools. She was quite artistic and painted watercolor pictures and made intricate Chinese-style paper cut-outs. Boothie spent her time off-campus at the Art Institute in Chicago and other similar gathering places. She was a woman well-ahead of the times. I admired her spunk and sense of humor. I still have a watercolor she gave me of two small boys dressed in traditional Chinese costumes. She also sent me a pretty, red, intricate, lace-like cut-out in 1931, when she went back to China. Both pictures hang on the wall above the table in my dining area.

Boothie and I managed to maintain a warm and friendly correspondence by writing letters back and forth for years after we graduated. I still have some of her letters and cards in an old suitcase which I keep in the basement atop my steamer trunk. I remember when Boothie had to return to China, she sent me postcards and letters from each of her stopovers. I followed her homeward journey from Hawaii to Australia to Singapore and to China. She wrote in one letter that I should come to China on my honeymoon. Well, I never got married, and I never went to China.

During the 1930s period of political unrest in China, Boothie's family had to flee the country. She went to live in Australia, and I don't know what happened to her after that because, I'm sorry to say, we lost touch with one another. The last thing I knew about Boothie was that she was married and the mother of two small children.

Another special memory I have from my Northwestern University years is of Dr. Tittle. He was the minister of the Methodist Church I attended while living there. The core of his Sunday sermons focused on a theme from which he created a simple phrase which he would use at the beginning, middle, and end of his homily. This message stayed with me throughout the week.

I remember one Sunday, Reverend Tittle gave us a lesson from the Book of Ecclesiastes, reminding his flock that, 'We should keep God's laws whether keeping them resulted in happiness or sorrow.' I thought his lessons were inspirational, and I began recording them in a little black notebook which I kept by my bedside so I could read and reflect on them before I fell asleep. They became my weekly guideposts."

Lola's graduation from Northwestern on Monday, June 17, 1929, was a special day in her life. She earned a college degree when few women even graduated from high school. In July, 1929, almost immediately after the ceremony, she took a full-time job with the A. J. Nystrom Company.

"At first, I made $18 a week. Later, my salary rose to $35. I paid my parents room and board and paid for my transportation to and from Nystrom. Each morning, I took the 6:44 train to Chicago, walked to Madison Street and boarded the elevated train heading for Twenty-Second Street. Then I walked four or five blocks to the Nystrom's office. Later, the

After Lola graduated from Northwestern, she took the train out of Barrington to Chicago on a daily basis, returning each evening to her parent's home. She continued to work even during the Depression.

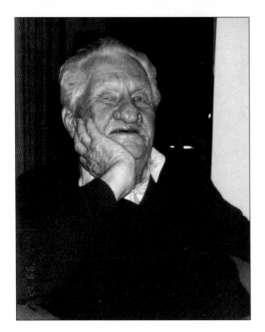

Raymond H. Andersen and Claudia Manderbach are long-time Barrington friends of Lola. The trio met at the Methodist Church where Lola has been a member for almost 80 years.

company moved farther north, around the 3300 block of Elston Avenue, making my commute shorter and less tiring and saving me money.

Like my dad, I continued to work during the Depression. My salary was cut, but I worked every day. Some departments had drastic cuts, and many employees were lucky if they worked three days a week.

I encountered Mr. A.J. Nystrom several times. He was a strictly-business kind of man. I never saw him smile. His son and daughter worked in our building during their summer vacations. They seemed quite nice, though I never became close friends with them."

Lola paused for reflection, and the conversation took a new turn as I asked Lola about the people in the picture that was sitting in a prominent space on her piano.

"Oh, that's my brother, Jim, and his wife."

"Do you see much of each other?"

"Well, they call me once a week, and they come to visit whenever they can. Jim was my dad's pride and joy, especially after World War II when he returned from his tour of duty. My dad couldn't do enough for him. He recently retired from Dow Chemical Company where he worked as a chemist for over 30 years. Both my brothers were scientific geniuses. Perhaps I could have joined their ranks had I become a math teacher or CPA instead of being a secretary at Nystrom, but I'll never know."

Ray Andersen, another of Lola's long-time friends, says he regards her as an inspiration for seniors. "She is one remarkable, spunky, spry lady. Claudia Mandalbach and I often go out to lunch with Lola and not long ago, when she needed to renew her driver's license, we drove her to the Woodstock License Center. After she was given the vision portion of the exam, the examiner told her she had failed. 'We'll see about that,' she quipped."

Lola promptly called her ophthalmologist and Ray and Claudia drove her to his office.

After he examined her eyes and adjusted her glasses, he said she could see "just fine." Ray and Claudia drove Lola back to the licensing center and she was reexamined. She "aced" it. Afterwards, the examiner smiled and said, "Ms. Rieke, I would drive with you any day." he just looked up at him and smiled.

One of Lola's most painful setbacks came on October 28, 1998, when her beloved Methodist Church, then under construction, caught fire and quickly burned to the ground. "I have been a member of that congregation for 75 years. Who would believe that whole thing would just go? You know you don't think you are emotionally attached to a building, but when I saw the video of the fire sweeping through the church steeple, windows and walls, I wept."

Lola's friends maintain that her unflagging optimism is bolstered by her deep religious faith. She is an unassuming individual who prefers that conversation focus on others rather than on herself. She is also admired for her independent, youthful, and compassionate spirit.

When asked what advice she would give to young people, Lola beamed and said: "Tell them to read the classics, travel, and learn whatever skills they need for the new century. Work hard. Find people who can give them career advice, the kind no one gave me at a time in my life when I really needed it. Let them choose their careers, let them follow their passions, and never let anyone deny them their dreams."

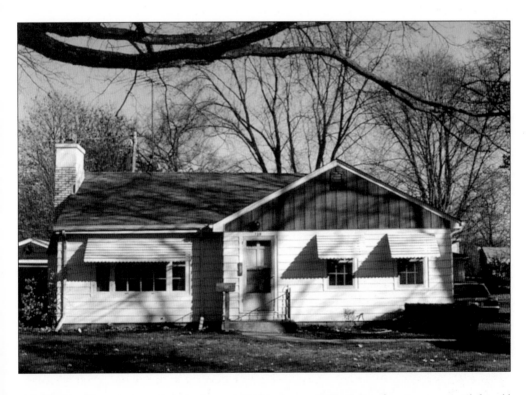

Lola lived in this modest, two-bedroom home on Prairie Avenue in Barrington for many years until she sold the property and moved to Lake Barrington Woods, a retirement community near the village she loves dearly. The house was filled with travel treasures, as well as years of memories.

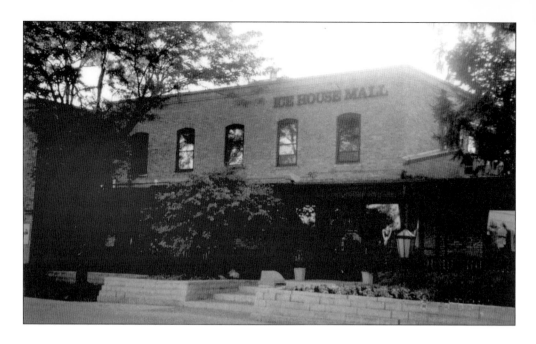

Barrington supports several thriving commercial centers: The Ice House Mall embraces the core of downtown Barrington. It was converted from the Bowen Dairy, originally built in 1904. The building once housed the Jefferson Ice Company, as well. These early businesses were built next to the railroad tracks near Harrison and Applebee Streets. By owner agreement, the dairy would blow its signal to alert volunteer firemen and residents of a fire in the town. The bright-yellow C&O railroad car that sits on the front lawn of the property is a reminder of the significance the railroad has played in the history, growth, and development of the community. Morning commuters continue to appreciate the speed with which trains take them to Chicago.

III.

Harold Lipofsky

M y mother, Bessie Lipofsky, kept a strictly kosher home and followed the dietary rules of our religion. Each week, she took the train to Chicago to buy correctly prepared meats, breads, and other traditional Sabbath foods. Every Friday at sunset, she lit candles in our kitchen window in honor of the holy day. Neighbors enjoyed seeing the candles' flame at sundown and recognized them as a symbol of our family's strong faith.

Samuel D. Lipofsky (my dad) and his siblings fled Eastern Europe searching for a better life in America. It was their ambition to earn enough money to pay for their parents' passage to America, too, but that never happened. At 13 years old, with only $50 in his pocket, my dad left Latvia. He carried a robust work-ethic with him and instilled it in all of his children.

Dad settled in Barrington and became a pack-merchant selling clothing and household provisions to customers as far away as LaSalle-Peru, a trip which took him 65 miles southwest of Barrington. In the winter, it was not uncommon for him to skate down a frozen Illinois River with a bag of supplies strapped on his back. For protection, he carried a side arm. Within a few years, Dad saved enough money to buy a wagon and open his first store: one on wheels.

In 1896, when Dad was 16, he opened Lipofsky's Department Store in downtown Barrington on Railroad Street. To start his business, he had to establish credit, fill the store with merchandise, purchase fixtures, and buy even the wooden crates in which to deliver his goods.

For a while, my father also owned a small store in Lake Zurich where there was a public telephone. He was the first telephone operator in the community and was known for offering to drive people into town so they could use the phone. After a few years in Lake Zurich, Dad sold that store so he could focus solely on the Barrington location.

The Lipofsky Department Store was always a family-run business. We all took turns working at the store. From a very young age, my brothers and sister helped Dad manage, maintain, and stock the store. I was the youngest, and I was put in charge of creating toy

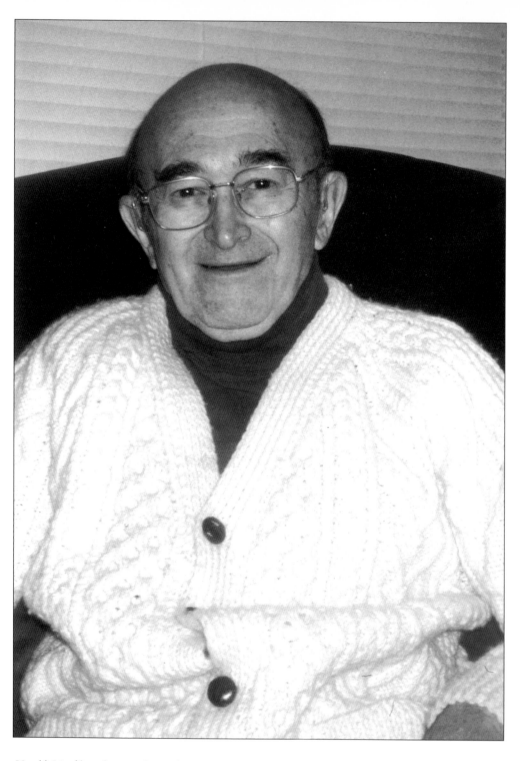

Harold Lipofsky relaxes at home during a recent interview. He is still busy full-time with plans for the construction of Harold Square.

displays. The best part of my job was that I got to play with all the new toys before I had to shelve them. At first, our store was modest. We carried primarily the basics: scout uniforms and equipment, school uniforms and gym suits, Levi's, ladies' cotton dresses, and the like. My sister Irene was the buyer. She enjoyed outfitting local women. After interviewing a woman to determine when and where the costume would be worn, Irene would choose a fully coordinated, *haute couture* ensemble for her client. She also created a dazzling, up-scale gift boutique— the first in Barrington—in the corner of the store.

When Dad started his business, he sold groceries, as well as notions and yard goods, but when he moved the store to Cook Street, he left out the groceries, making Lipofsky's a full-service department store commonly referred to in the business as a "junior store."

During the Depression, I remember my brothers, Henry and Franklin, suggesting to my dad that he turn the store basement into a bargain store where people could buy soap and other sundries at give-away prices. It was a superb idea. It brought people into the store, walking them past pricier merchandise on the first floor before they headed downstairs to purchase the merchandise being offered at a loss. Our business grew with Samuel, Henry, and Franklin's savvy. They managed to keep the store open even during the dark days of the 1930s.

As the years passed, every one of Dad's sons became a partner in the business. We even added a shoe department to provide another essential product for our ever-growing circle of customers.

In 1925, my dad died. I can still see him trying to catch his breath as he climbed up and down flights of stairs at home and at work. I learned a valuable lesson from Dad's passion for smoking: I committed myself to a healthier life-style, one that includes daily exercise, a heart-conscious diet, and total disdain for cigarettes.

When Dad died, Henry and Harold became partners, and when Henry died in 1962, Harold assumed control of the store's entire operation with the help of Henry's wife, Mildred. Ironically, Harold's beloved mother, Bessie, died the next day at the same hospital as his brother.

As I was a bachelor, the store became my life. Every morning around 8:00 a.m., I arrived at the store, unlocked the door at the rear of the building, stocked all of the cash registers, straightened up in each department, went out the front door, rolled down the striped awning, and then swept the sidewalk in front. By 9:00 a.m., six days a week, the store opened for business. I even accommodated late-working customers by keeping the store open Friday evenings, an innovative idea in the 1950s.

Ours was a buyer-friendly store. My job was to assist every customer. For example, if a lady came in asking if we had any size seven gloves, I could walk behind the counter, pull out a tray of dozens of pairs, pick up one and, with a salesman's flare, show her the product. My goal was to satisfy my customers by immediately providing the merchandise they might not be able to find in larger stores."

A long-time Barrington resident, Andy Kostick, relates a story that demonstrates the past importance of Lipofsky's Department Store to the community. "When my son was 15 years old, he took a job working in the kitchen of the Jesuit Retreat House located just south of Lake-Cook Road. Yuri was required to be dressed in white clothing from head to toe. We shopped all the major retailers for white jeans, going to K-mart, Sears, Penny's, and Wards. No one carried white jeans. Out of desperation, we decided to see if Lipofsky's carried them. When we walked into the store, Harold greeted us with a smile and asked if he could be of service."

"We're looking for a pair of white jeans," we said.

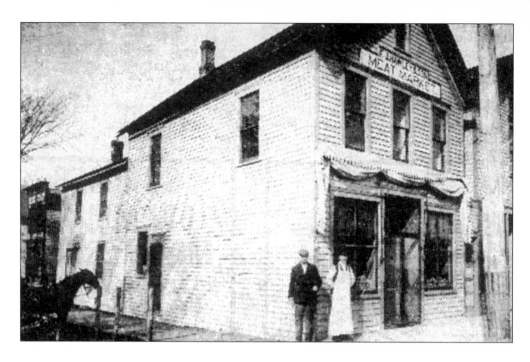

Lipofsky's corner as it appeared in 1916 when it was occupied by Frank Hawley's meat market. Standing in front of his store is Frank and his son Floyd. The photo on the bottom is Lipofsky's brick store, constructed in 1922 by Harold Lipofsky's father. Lipofsky opened the original store in 1896.

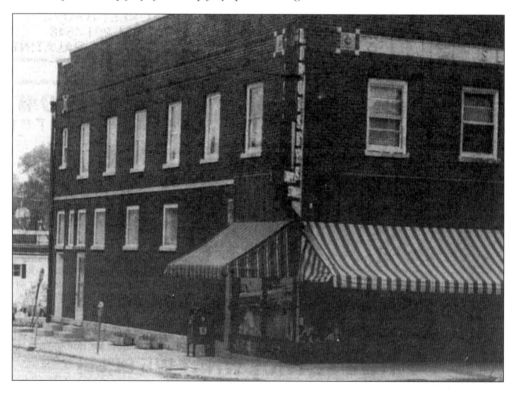

"Come this way, I have plenty in the basement," responded Harold.

"Indeed, there were stacks and stacks of white jeans of every length and width. The search for those jeans demonstrated to our family that Lipofsky's Department Store stocked an enormously wide selection of wares. After the jeans search, we always checked at Lipofsky's first when we were looking for anything basic. Barringtonians quickly came to know that Lipofsky's was a 3-floor treasure-house of countless sundries and furnishing," Andy concludes.

"I was not only the proprietor of Barrington's only department store, I was the only member of my family to serve in World War II . When the war came, my brothers had medical or family deferments. I was turned down twice by the Board of Recruits, but on my third try, they accepted me without hesitation and in 1943, I was inducted into the Army on my birthday, September 20. First, I was assigned to basic training at Camp Grant in Rockford, and then I was transferred to Camp Wheeler in Georgia. The Army wanted to put me in an Intelligence Unit, but I declined their offer, preferring regular duty. On March 19, 1944, I was shipped out to a base near Naples, Italy, where I became part of the Army's 22nd Deposition Division and was assigned to the Message, or Code, Department. Our Division had to process the necessary paperwork for any soldier who was being deployed anywhere the Army had a need.

In Italy, I contracted malaria and was put on light duty. I was told to report to the base commander who sent me to the 27th Depot Division. There, I drew assignment cards for men who were being sent to other locations on the continent. Twice, I drew my own card, but the general saw my card in the allotment and withdrew it and nine others as well. He assigned us to a new outfit called Replacement and Training Command.

I earned one bronze star during my tour of duty. They were given to anyone who served anytime, anywhere in a war zone. The more stars a soldier acquired, the sooner that soldier would be sent back to the states, but it also meant that the soldier had seen time in a combat zone.

I had a strange experience while processing one of the assignment-cards. I had been in basic training with a group of fellows who played cards every night. They were quite noisy and made it difficult for the rest of us to get a good night's sleep. One night, I mentioned in passing to one of these guys that I wouldn't want to be at the front with any of them— they weren't dependable.

Then, several months later, when I was shuffling through the assignment cards, I came across this same man's name. On a note card it indicated that he was being sent home because of the many battle stars he had earned from seeing so much action. I was humbled by that experience when he said to me, "I would have taken good care of you, Smitty." (Most of my superiors called me 'Smitty' because they could not pronounce Lipofsky.)

After the war, I returned to Barrington and resumed my position running the store and I enjoyed it for the next 50 years. Then, early on the morning of Monday, December 18, 1989, tragedy struck. A fire started near the ceiling of the store. I was in the basement cleaning up some papers left over from the night before. Looking around, I noticed a small fire along one wall. I aimed an extinguisher at the flames, emptying the canister. I thought I had completely doused the flames, but smoke continued billowing through the store. I was unaware that heat and fire were spreading between the rafters and the ceiling. Unfortunately, the expanding fire had gone unnoticed the evening before and after the store was opened that morning.

When the emergency crew arrived, I told them where I thought the source of the fire was. I expected them to head right into the building, move directly to the location I

REMOVAL SALE BARGAINS

Sale Starts Friday, Aug. 17

Arm and Hammer Soda, 1 pound packages............................5c

Santas Coffee, per pound..22c

U. S. Mail Soap, 8 bars...25c

Ladies' Middy Waists, $2 quality...................................98c

Ladies Crepe Bloomers, to close out...............................48c

Misses Union Suits, all sizes 75c grade...........................35c

Arrow Linen Collars, prices 20c everywhere — this sales..........14c

Men's Florsheim High Shoes . . . cost...........................$8.45

Knee Pants, all wool, 8 to 19 years..............................$1.98

Men's $2.50 Felt Hats, you'll need them soon....................$1.00

Men's Balbriggan Underwear, to close out at.......................39c

Ladies' Silk Hose, in black only..................................48c

Lace Torchon, extra fine, per yard.................................5c

Boys Suits ...$9.48

Straw Hats, 35c and 50c quality...................................19c

S. LIPOFSKY

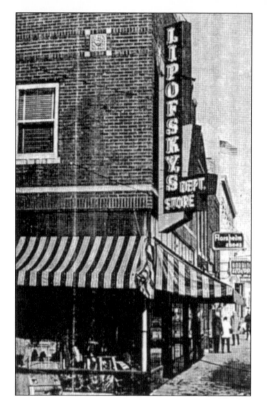

This ad appeared in 1922, when Lipofsky's was located at 118 South Cook and had been "serving the community since 1896." (Photos on this and the previous page courtesy of Barbara Lipofsky Marsh.)

Samuel Lipofsky began a dry goods store in Barrington in 1896, when he was a mere 13 years old. The store remained in the family until it was destroyed by fire on December 18, 1989. For decades, Lipofsky's was the headquarters for Boy Scout and gym uniforms.

indicated, and extinguish the fire. To my astonishment, the men responded, 'We're paramedics; we can't go in.'

By the time firemen arrived, the windows had been blown out by the first of two explosions. The fire was out of control. Numb and in shock, I realized the store was lost. Firefighters from eight departments battled the blaze for over five hours, and several rigs remained at the site well into the next morning. It's a blessing there were no injuries. One employee tried to go back into the store to get the purse she left near her work station on the third floor. And there was a man in the dressing room at the time of the fire. He was trying on a shirt. He took it off, buttoned it, left it on the chair, and fled the store. I was flabbergasted by the man's story when he later related it to me."

With looks of horror on their faces, a sizable crowd gathered to witness Lipofsky's Department Store being seared into Barrington's history. Floating ash and smoke fanned by the fierce December winds settled all over Barrington's downtown business district and adjacent communities.

"The day after the fire, I began my morning in the usual way by clearing the sidewalk of the past night's snowfall. I removed the debris, too, so pedestrians could walk unhampered. Standing before the 93-year-old structure, which was a wet and still-smoldering shell, I thought about how this store hadn't been just a business: It was a major part of my life.

When I saw the extent of the damage, I decided not to rebuild. I have no children, and, at my age, I wasn't sure how long I could continue to run up and down the stairs of another 3-story building. In truth, if I couldn't manage the business, I thought it would be difficult to sell it."

After the disaster, Harold turned his attention, time, and energy to other projects—especially to Harold Square, a plan he and his partners hoped would revitalize downtown Barrington. Their idea was to buy out the few merchants whose buildings Harold did not own and then raze the whole block. They planned to build a 4-story structure that would include underground parking, space for offices and businesses, as well as 60 condominiums. It was the largest downtown development project ever planned for Barrington.

The architect, Ben Borkon, stated that the proposal would offer residents a place to park, shop, live, and relax with friends and family over a good cup of coffee. "We thought Harold Square would to be a solution to Barrington's on-going economic woes and the disorder created by the mix of building designs in the area," Borkon said.

They planned to lease store space to The Gap and Walker Brothers Original Pancake

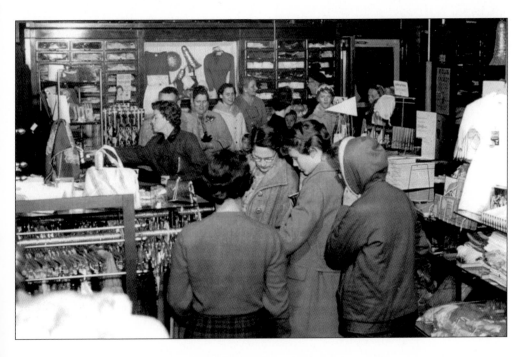

Christmas shoppers crowd Lipofsky's for last-minute items. The store had three floors to serve its customers. The family-owned and -operated, "it-had-everything" store was destroyed by fire early on the morning of Monday, December 18, 1989. (Photos on this and the previous page courtesy of Barbara Lipofsky Marsh, c.1960s.)

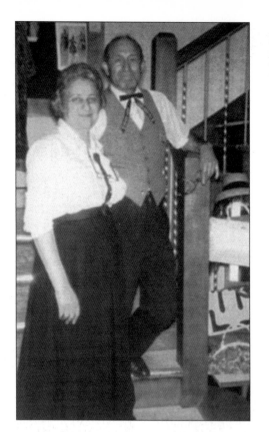

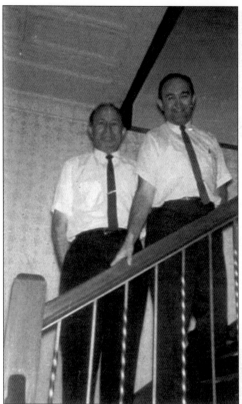

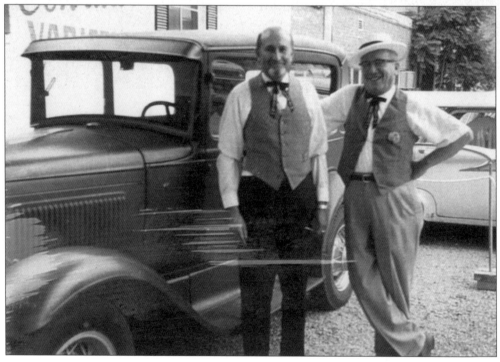

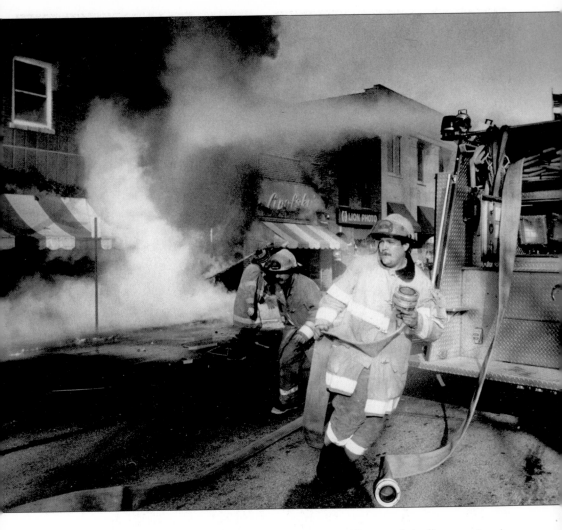

Above: *Barrington firemen work to save Lipofsky's Department Store. However, their efforts were in vain and the landmark store could not be kept from the fire's windswept flame on December 18, 1989. (Photo courtesy of Pioneer Press.)*

Opposite, top left: *Standing on the steps of Lipofsky's store, are Mildred and Henry Lipofsky dressed in costume for Barrington's centennial in 1963.*

Opposite, top right: *Brothers Henry and Harold overlook the first floor of the store which the men co-owned and operated. Lipofsky's Department Store combined the best of today's K-Mart, J.C. Penney, and Kohl's. In its day, it was ahead of its time and its loyal clientele supported the store from the day it opened.*

Opposite, bottom: *Harold Lipofsky, on the left, and Abe Bender, owner of Bender Reiger Pontiac, stand beside a classic car, which was used during the Barrington Centennial activities in the summer of 1963. The men are standing in front of Conrad's local shop. Long-time friends and pillars of the community, these men represent small-town businesses where they knew their customers on a first-name basis.*

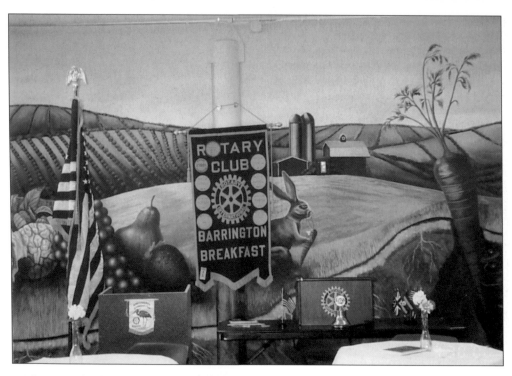

Rotary is one of the most popular service organizations in the world. There are approximately 1.2 million members of whom about 90,000 are women. There are 30,000 clubs in more than 160 nations. Rotary International can be found in places as diverse as Cambodia, Kazakhstan, Pakistan, India, Australia, South Africa, Iceland, Turkey, Mongolia, and Bangladesh.

Harold Lipofsky has been an active member of several service clubs for decades. He has been honored to serve as the district governor of Rotary International District 644, covering 47 rotary clubs, and one provisional club in northeastern Illinois in 1984. During his tenure, his district was responsible for inoculating 40,000 people with the polio vaccine. In 1985, Rotary International launched PolioPlus, a 20-year commitment to eradicate polio worldwide. As the program grew, so did Rotary's involvement. By 1990, Rotary moved from providing polio vaccine to children in developing nations to assisting health care workers in the field. The goal is to see polio eliminated globally by 2005. "In essence," said Lipofsky, "Rotary is dedicated to promoting international understanding and world peace on a personal level."

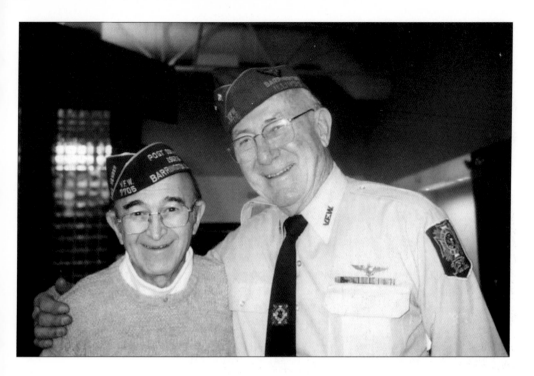

Harold and his long-time friend George Van Hagen have participated in the activities of many service organizations on behalf of the citizens of Barrington. Both men are veterans of WORLD WAR II and are actively involved in Veteran's work throughout the area. They are truly dedicated to helping others in any way they can.

House and courted several other national chains that they hoped would move into Harold Square to serve as anchors. At the time of the proposal, Chamber of Commerce President, Carol Besse, considered the concept of Harold Square premature and winning Chamber support and Village approval was more challenging than the partners expected. Now, several years after the project was unveiled, and after modifications have been made to meet Village Board requests, the project remains merely a blueprint.

Lipofsky has not given up on Harold Square, but he has turned more of his energy and time to civic services. Over the decades, he has been involved in numerous community organizations, sometimes serving in leadership roles. Harold is a founding member and past president of the Barrington Association of Commerce, known today as the Barrington Chamber of Commerce.

The original association was created by 40 local business members who were dedicated to helping one another plan sales and promotions, and even purchase Christmas decorations for the downtown area. Their goal was to make the heart of Barrington a more physically and commercially viable center for consumers who want to shop in an upscale, yet small-town, atmosphere.

Another of Harold's civic ventures was serving on the Barrington Board of Trustees. He chaired the Village Human Relations Committee for several years and found this work to be most rewarding. He fondly remembers being part of one committee that oversaw several road improvements throughout the Barrington community. In keeping with his

humanitarian ideology, he has committed himself to making the Barrington community into a place where diversity is respected, appreciated, and celebrated. In 1979, the Chamber of Commerce presented Harold with its Award of Merit. Roy Klepper, a Chamber member at that time, told the audience that the award "is given to an individual, corporation, or association which has added to the betterment of the Barrington area business community. Few people have contributed more to this goal than Harold Lipofsky."

"I was surprised and honored to receive the recognition," said Harold. In his acceptance speech at the Barn of Barrington, he joked that when he heard the list of his accomplishments, it sounded like someone was reading his obituary.

Leagued with his work for the Village, Harold is a charter member of the Barrington Rotary. According to his long-time friend, Hugh Frebault, "When Harold was first invited to join Rotary, he hesitated after learning that the group's monthly meeting lasted from 12 p.m. until 1:30 p.m. Harold allowed himself only one-half hour to eat lunch. Every day he crossed the street, entered the cozy Town Shoppe, ordered a bowl of soup or a sandwich, ate quickly, and returned to the store. But, after I talked more about Rotary to Harold," Hugh continued, "he decided to give it a try."

Since 1960, Harold has not missed a single meeting, was president from 1978-1979, and had the distinction of serving as a District Governor from 1984 to 1985. It was also during this period that Rotary International set a goal with the World Health Organization of eradicating polio by the year 2005.

"The first year of the program, 40,000 people were inoculated, and polio's hold on third-

Harold Lipofsky, a World War II veteran, and his friend Tom Gibson, a Vietnam veteran, attend Prairie Middle School Veteran's Day, student-sponsored breakfast and assembly.

world nations diminished. But today, polio is again appearing in remote regions of several continents. Joint efforts of the Rotary and WHO continue to fight this dreaded disease," Frebault said.

Harold reported that a related concern for him is a new polio syndrome that affects those people who had seemingly recovered from polio they contracted years ago, but who are now suffering from, and dying of, a reoccurrence of the disease. "Today, these people are being suffocated by a disease they thought they had licked years ago," said Harold. "And the sad part is that most people don't realize what is happening to them, nor does the medical profession recognize the symptoms soon enough, which leads them to misdiagnose the new manifestation of the disease."

At the January 2000 meeting of the Barrington Rotary, members celebrated its 40th year of community service. At that monthly meeting, the organization surprised Harold by showing its appreciation for his efforts on Rotary's behalf. They presented him with a plaque of recognition for his "outstanding contributions," and the members gave him a standing ovation.

Hugh Frebault believes Harold probably holds the record for participating in the most International Rotary Conventions held throughout the world. At a recent gathering, Harold quipped, "I've been attending these get-togethers for so long that I'm now on a cycle of revisiting convention sites and cities."

Harold has also been active in the Signal Hill Chapter of the Boy Scouts for three decades. Over the course of his years of service to the organization, he has sponsored five scout packs, raised funds for the Roy Wilmering Scouting Cabin, and served continuously

After the fire which demolished Lipofsky's Department Store, local artists and Rotary Clubs created a park-like setting for Barrington shoppers to rest and relax on sunny, warm summer days.

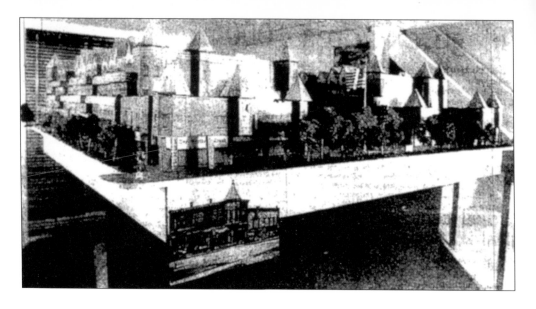

At the top, is a model of the proposed Harold Square development, which the planners say replicates the look of Barrington in 1910. When fire gutted Lipofsky's Department Store on December 18, 1989, Harold promised the community he would rebuild on the site. The long-postponed and frequently revised plan for a combined retail and condominium complex has been reviewed once more by the Barrington Board of Trustees. It appears that Harold Square will finally become a reality as the Chamber of Commerce and other community organizations seek ways to revitalize the Barrington's downtown district. (Photo courtesy of Barbara Lipofsky Marsh.)

on its Board of Trustees. He enjoys working for the betterment of children's lives, and all during his life, he has never ceased doing so. When asked to recall the most memorable event associated with scouting, Harold quickly responded, "It taught me how to sleep comfortably on the ground, lessons used later when I was stationed in Italy." Beyond that, of course, is the pleasure he experiences in watching youngsters learn, enjoy, and advance through the ranks of scouting.

Probably his most numbing challenge came when his beloved sister, Irene, passed away from heart disease. Her illness consumed Harold physically and psychologically. He spent time with her at home or at her hospital bedside every day until she succumbed to the disease.

Harold Lipofsky is steeped in Jewish traditions, family values, and community service. He has always taken immense joy from helping others. He is a happy, satisfied, quick-to-smile "gem" of a man. Harold lives in a cozy home in the heart of Barrington Village, a community which has warmly embraced this giant of service, humility, and dignity.

On May 22, 2002, the Barrington Area Council on Aging inducted Harold into the Barrington Area Senior Citizens Hall of Fame "for years of service that have enhanced the quality of life in the community."

IV.

Jack Noyes, D. V.M.

When local veterinarian, Jack Noyes, grew up in Barrington, farms and residential areas blended together. As a child, he raised chickens, rabbits, and kept a pony in his backyard. During the 1930s, while children in Chicago sold apples for pennies apiece, six-year-old Jack and his sisters, Nancy and Jean, sold pony manure. Several times during the week, the three Noyes children would fill their red Radio Flyer wagon with animal waste from the barn and sell it to gardeners and small-scale farmers living within walking distance of the Noyes' home on Liberty Street, charging a penny per load.

In addition to selling barn manure, the ambitious entrepreneur also sold rabbit skins to a man from Montgomery Ward. The pelts were used to make fur-lined gloves, a lucrative item for the store and for Jack. He also merchandised rabbits and chickens to Brockway's Delicatessen where the butcher was happy to buy fresh meat during World War II . The cash earned from these modest businesses provided Jack and his sister with spending money at a time when extra nickels and dimes were signs of wealth.

Lean, lanky, and hardly graying at the temples, Dr. Jack Noyes has always had a passion for helping and healing animals. By his sophomore year at Barrington High School, he knew he would either become a farmer or a veterinarian. Jack's 1948 yearbook has numerous references to his agricultural dreams. Classmate Bud Burnett wrote, "Jack, old buddy, we expect you to be a good farmer"—a typical reminder that his peers recognized Jack's early-on keenness for animal husbandry.

During the time that dairy and horse farms were prominent throughout the Barrington area, an energetic Jack took his devotion to animals seriously. He convinced local veterinarians Roy Zook and Bill Bauman to allow him to ride with them on some of their calls to nearby farms. He figured he was probably considered a pest by these two veterinarians, but they were wonderful mentors to their enthusiastic pupil.

"These marvelous men took me under their wings. They whetted my appetite to be of service to animals and their owners," said Jack, squaring his shoulders, his eyes glazed with

Dr. Jack Noyes is legendary in Barrington. Retired from decades of caring for cats and dogs and numerous other kinds of animals, this former high school football star now divides his time between his hometown community near his children and grandchildren, and Naples, Florida.

nostalgia. "Whether it was an emergency delivery of a calf, the sudden infection of several lambs, or cows down with fever, we were called to help."

On weekends, this dedicated youngster rose before dawn and rode his bicycle along Barrington Road out to the cornfields that straddled Mundhank Road. There, he would work alongside dairy farmers with their twice-a-day milking chore. He would spend each Saturday and Sunday on one of several farms, and at night, one of the men would load Jack's bicycle in the back of his truck and drive the exhausted young man home. "I never got tired of the thrill of being around animals," said Jack.

His compassion for the world of animals has never flagged. "At the beginning, my focus was on large animals. At the time I entered veterinarian school, almost everyone specialized in the treatment of large farm animals because that's where our income would come from when we graduated. However, over the years, the lifestyles of our animals have changed. Today, most of our pets have moved from living entirely outdoors to living totally indoors—and we don't keep many cows!" said Jack.

During his years at Barrington High School, Jack's social, athletic, and academic plate was full. He was a member of the BHS B-Club playing football and basketball, and running track. He sang in the Boys' Glee Club and joined the Spanish, Auto Mechanics, and Square Dance Clubs to round out his participation at BHS. After graduation, Jack headed for Purdue University where he worked odd jobs to earn enough money to purchase books and take care of his miscellaneous personal expenses.

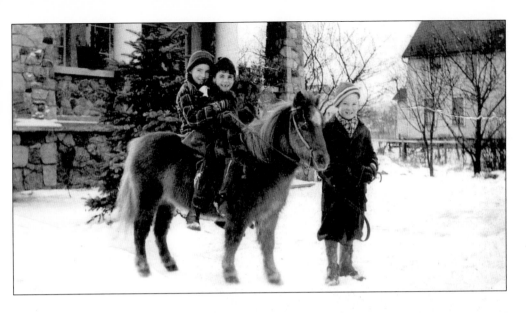

Jack Noyes holds the reigns while his sisters, Jean and Nancy, rest on their pony's back. (Photos courtesy of Dr. Jack Noyes.)

Jack's aspiring career almost came to a halt when he was 20 years old. While installing a metal window frame high on a scaffold at St. Anne's Catholic Church at Ela and Franklin Streets, he lost his balance and grasped the frame, pulling it free. It fell with him some ten feet to the concrete floor. The structure weighed close to 150 pounds, and Jack lay unconscious beneath the broken window. Workers on the job lifted the metal frame off him. He was examined at the site by a local physician who rushed him by ambulance to Sherman Hospital. Doctors despaired for Jack's life. He suffered a shattered skull and a crushed shoulder. But, after only 24 critical hours, he began to respond to treatment.

When his parents learned of the accident while out of town, they immediately rushed home. Doctors credit Jack's speedy recovery to his top physical condition. "That was a scary time for all of us, but I had good care, loving parents, and supportive friends who helped me through the ordeal," said Jack. The accident ended his football career, but he stayed in the Purdue athletic program as the manager of the baseball team.

Jack and Jinny met at Purdue and were married on October 4, 1952. In January of 1953, he graduated with a Bachelor's of Science in General Agriculture and credit for two years of pre-veterinary school. While at Purdue, Jack had been a member of ROTC for four years and received a commission as a second lieutenant in the Transportation Corps. After earning his degree, he was sent to a base near the 38th parallel outside Seoul, Korea.

"Because of my previous training, skills, and knowledge of motorized vehicles—which I had studied as part of Purdue's ROTC Transportation Corps—I was assigned a commission in the Transportation Department. As a novice Army officer, I was put in charge of a sizable truck company handling cargo from the port to the front lines. I was happy working with the men under my command because, like them, I enjoyed being around and fixing mechanical equipment. We had some good times in Korea, and I learned a good deal about Korean culture from my stint in this stunning, mountainous region of Asia. I've kept a scrapbook full of photos from my Korean years," said Jack.

"Our son, Billy, was born May 24, 1954, just prior to my being shipped to Korea. After Korea, I came home with an honorable discharge and, with money from the GI Bill, I enrolled at the University of Illinois School of Veterinary Medicine. To support my family of three, I worked various jobs for the University Veterinarian School, earning $1–$3 per hour, and working 20 to 40 hours per week. I painted window mullions; cleaned, painted, and fumigated animal cages; fed, watered, and took temperatures for gerbils under study; and I scrubbed the lab where animals that had mysteriously died were sent to be autopsied.

Our family also managed financially because my wife, Jinny, taught school half-days. Finally, I completed my course of study and earned my Doctorate in Veterinary Medicine in 1959. Our daughter, Mimi, was born on February 26, 1960. At that time, we moved to Barrington, and I began my veterinary career working for my former mentor, Dr. Roy Zook. Just a year after I joined the practice, Dr. Zook died of a heart attack. I purchased the clinic and started my one-man practice in 1961. As a young vet, it was not unusual for me to work 80 to 90 hours per week."

While the number of farms in the Barrington area had dwindled since Jack had left for college, there were still many nights when he would be summoned from bed to attend to a pig, lamb, or cow. He would return home in the early morning hours, get a little sleep, and be at the clinic before 9:00 a.m. When Jack started practicing in Barrington, raccoons, skunks, and ocelots were popular pets. Today, they are illegal and veterinary care centers around horses, dogs, cats, and other small house-pets.

Over the course of 40 years as a veterinarian, Dr. Jack Noyes has had a myriad of humorous

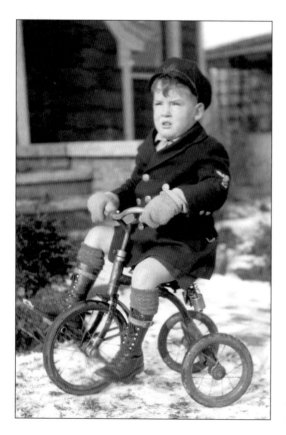

An intense, three-year-old Jack rides his tricycle at winter's first thaw.

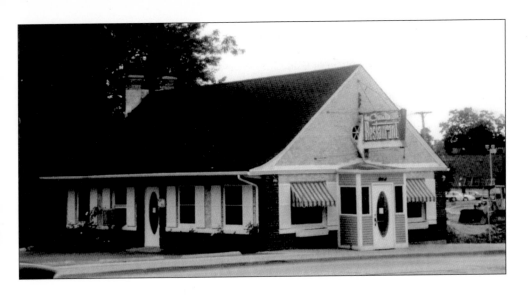

The Canteen Restaurant has been a fixture in Barrington for generations. It has been the gathering place for teenagers, shoppers, and seniors and has witnessed the growth and development of the downtown area over the years. Jack and his friends often took their dates here for Cherry Cokes or a chocolate phosphate.

animal-treatment tales. "One story that quickly comes to mind is about our neighbor's boxer. You see, this breed is prone to swallowing objects. One day, the dog's owner arrived at the clinic with his pet in tow. The man reported that the animal had swallowed a 4-inch rubber ball. We carried the dog to the examining room, and I took several X-rays which revealed the ball lodged in the animal's stomach. I knew the ball was too large for the dog to eliminate it, so I told the owner that his pet would have to undergo surgery to remove the object. I looked at the poor dog who was completely preoccupied with his internal discomfort.

Just prior to surgery, I administered a small dose of morphine to help the animal relax. Minutes after the injection, the dog began to vomit. Up came the red rubber ball. So, I phoned the boxer's owner and said, 'Come get your dog, he won't be needing surgery.'

Another vivid pet-story was about a lovely Golden Retriever that was hit by a car. The owner, a Budweiser distributor for the Northwest section of Chicago, was quite distressed when he arrived at the clinic. He carried the badly injured dog into the hospital and helped me get the animal up on the examining table. One look at the shattered, right foreleg convinced me that the leg needed to be amputated, but the owner begged me to save the dog's limb. After much pleading, I agreed reluctantly to try my best to repair the dog's leg, but I made him no promises that it would heal properly. The operation took hours as I pieced the bones together and inserted several pins and rods. I kept the dog at the clinic for several days in order to observe him at close range.

Weeks later, I X-rayed the retriever and saw that the bones had not joined. I reported the problem to the dog's owner. I told him there really wasn't anything more that I could do for his pet. Again, the man pleaded with me to try something, anything. I told him that I would contact some veterinarian friends from Michigan State University who specialized in canine orthopedics. They recommended that I try a bone graft to repair the injury. It was my first experience with the procedure. Yet, within a month, the Golden Retriever was up and mobile. The owner was so appreciative that he loaded his station wagon with cases of

Budweiser and drove the beer to our clinic. Stack by stack, he filled the entire waiting area. My receptionist was concerned; she called me at home and asked what she should do with the beer since office policy prohibited alcohol on the premises. I told the staff to load their cars with the beer and when I returned to the clinic, I would take home whatever beer remained. I can assure you, we all had plenty of beer for quite some time to come."

The natural-born storyteller continued, "This one is about a cat. A family had had fish for dinner and put the bones into their disposal but had forgotten to grind them before they went to bed. At 4:00 a.m., they heard their cat's raucous wailing. They flew downstairs and saw that the cat had gotten its head caught in the disposal while in the process of retrieving the bones.

The family did what they could to free the cat's head, but they were unable to liberate their pet. Frantic, at 5:00 a.m., they phoned an on-call plumber who came and tried to release the cat by taking apart all of the kitchen plumbing, but the cat remained lodged in the disposal. At 6:00 a.m., the desperate family called my clinic. When I heard the recording, I called their home to get more information about the cat. They gave me directions to their house, and when I entered the kitchen, I saw their "headless" cat. The first thing I did was give the cat a mild anesthetic. Then, I said to the owners, 'Get me a bottle of olive oil.' I poured the amber liquid all around the animal's head, soaking its fur. Next, I put my hands around the cat's torso and began tugging on the terrified creature. In seconds, the cat was free. By now it looked terrible with bulging eyes, swollen face, and purple tongue. I drove the terrorized cat back to the clinic and treated it for shock. That same day, it was its old self, and I sent it home with its owners who never again forgot to empty the disposal."

In 1979, to celebrate their 25th wedding anniversary, Jinny and Jack planned a trip to the British Isles. Before leaving for England, Jack wrote to James Herriot, the famed veterinary-

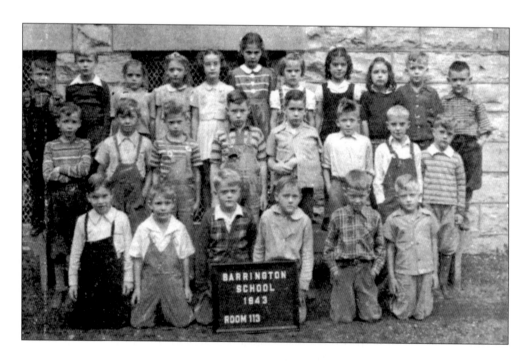

Jack Noyes and classmates from the Hough Street School class of 1943.

46

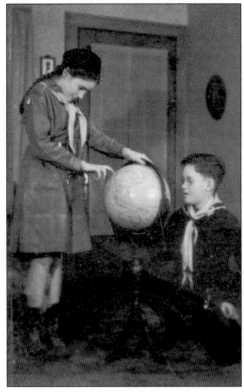

Cub Scout Jack explores the "world" with an unidentified Girl Scout. (Photos courtesy of Dr. Jack Noyes.)

"Cowboy" Jack Noyes awaits his "pardners."

author, asking if it would be possible for him to spend five minutes at his legendary clinic. Herriot wrote back and set up a time for Jack to come to his clinic; however, Herriot's letter also cautioned, "I'll be able to meet with you at 9:00 a.m. on July 23, God willing there is no emergency in the country." British country vets are frequently called away from their surgeries at a moment's notice. When Jack arrived in the little town of Thirsk, 35 miles northwest of Yorkshire, a tweed-clad, frayed-at-the-collar-and-cuffs James Herriot greeted him warmly and took him all around his surgery.

"I was astonished by Herriot's hospitality, his well-equipped clinic, and the vast, verdant countryside. After my visit, I took our rental car and drove all around the area. It felt like I had been there before because of the detailed way in which Herriot had portrayed the hundreds-year-old homes, the hills, dales, narrow roads, and miles of rock fences in his marvelously poetic books. We have an autographed photo of James Herriot and his surgery which I treasure."

Veterinarians are not presented with medals for bravery or for helping sick animals in cold and drafty barns, but Dr. Noyes has been recognized internationally by his colleagues for pioneering both an awareness of the treatment of heartworm disease and canine dental care. At a time when few veterinarians knew much about heartworm disease, Jack made numerous appearances on radio and television and wrote countless articles for

Jack served as president and secretary of the school board during the construction of Barrington Middle School. The innovative school boasted team teaching, movable walls, and flexible scheduling, and drew visitors from around the world. (Photo on this and page 51 courtesy of Barrington Middle School-Station Campus.)

newspapers and journals to educate his fellow practitioners about this life-threatening disease. He also has spoken on the topic to veterinary groups in Canada and Australia. And, in 1987, when a once-a-month (rather than daily) heartworm pill was approved by the Food and Drug Administration, Jack went on tour to promote the improved medicine.

Few people know that their pets can suffer from dental diseases, but Jack Noyes does. While President of the Illinois Veterinary Medical Association, he also brought this subject into focus for fellow veterinarians and pet owners, often speaking about the importance of preventive dentistry. Like their owners, dogs and cats can lose their teeth to dental disease. Untreated, it can also damage their heart valves. Thanks to Jack's promotion of proper dental care, veterinarians today routinely advise pet owners to have their animals' teeth cleaned to maintain healthy teeth and gums, and to prolong their pets' lives.

Dr. Gery Herrmann, one of several former Barrington High School students who became veterinarians after working at Noyes' Clinics, remembers watching Dr. Noyes perform a root canal on a dog. "That was quite an unusual experience in those days. In fact, it is not totally common, even today."

Eyes flashing, Jack continued his conversation about the revolution in pet practice. "We vets coattail what is available to physicians. Like human care, pet care has become specialized. In most cases, these specialists use high-tech equipment, and the practitioners have been taught at centers concentrating on specialization. What is interesting is that these experiments used to go from dogs to humans; now it seems to be going in the other direction.

Though many pet procedures are expensive, it isn't always the affluent who are willing to pay for them. People sacrifice themselves to care for their pets, and what people are willing

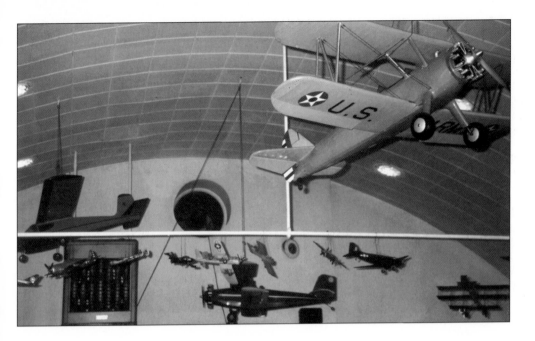

Canteen owner Tony Caliento served bacon and eggs, hamburgers and fries, along with meatloaf and hand-mashed potatoes. The restaurant, known for its ceiling full of airplane models, became the hangout for students—including Jack—before and after school.

to do is not determined by their economic bracket," said Dr. Noyes, who can't imagine his life without a dog at his side, whether it is at home in the family room, or out in the field hunting. "The future holds encouraging possibilities not only for extending the lives of our companion-animals, but for making it 'quality time' for both of us," said Jack.

On May 28, 1991, Dr. Jack D. Noyes, D.V.M., was honored as a Distinguished Barrington High School Graduate for the years of work in his profession. In addition to many awards and honors, Noyes has held high office in several professional associations, including the Illinois State Veterinary Medical Association, the American Heartworm Society, the Midwest Small Animal Association, and the Lake County Veterinary Medical Association. "Everyone was involved with my practice. Jinny kept the clinic's books for 34 years, and both of our children worked at the hospitals. While in high school, Billy mowed the 4 acres of grass, cleaned cages, scrubbed the examining rooms, and fed and exercised the animals. He was a hard worker who constantly helped at the clinics. Today, Bill and I are even business partners. Our daughter, Mimi, came aboard when she was just 13. It was Jinny's idea. There were a number of 'wild' boys living in our neighborhood at that time, and Jinny didn't want Mimi associating with them. So she asked me if I would take Mimi to the hospital. I agreed, and the first thing I did when Mimi came to the clinic was sit her down and have a talk with her. 'Now, Mimi,' I said, 'when children are the boss's son or daughter, a lot of times they do the least amount of work, and they think they can sit around and do next to nothing. But that's not the way it's going to be here. Being the boss's daughter means you have to set the example, and you have to work harder than the other employees.' Mimi caught on quickly and she hustled and did her share and more. In fact, she worked for me from the

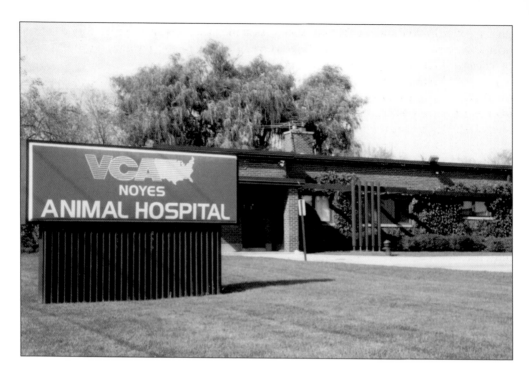

Dr. Jack Noyes sold his veterinary practice on Northwest Highway, but the clinic retains his name.

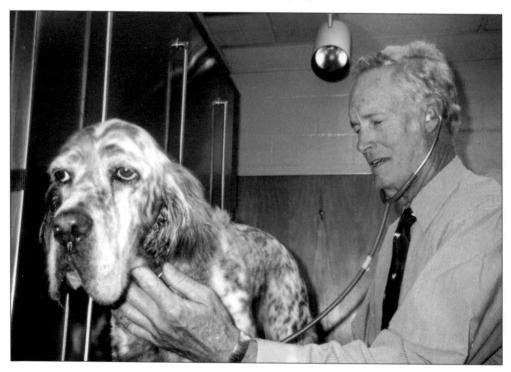

Jack performs a routine exam on his friend Mack at the clinic.

time she was 13 until she was 21. She would assist me in surgery, answer the phones, clean up the examining rooms, and just do whatever I asked. I can't imagine my 40 years of practice without my family being at my side."

Jack has also been involved with several community organizations. He was president of the Barrington District #4 School Board, a member of the Chamber of Commerce, and he worked for the Lions Club and Boy Scouts. Dr. Noyes is still active with Barrington High School. He helps organize the reunions for the Class of 1948. For the 50th anniversary, 35 graduates and their spouses attended festivities held at Chessie's and the Millrose Inn. Annette Sheel and Grace Wandtke, two teachers who taught at BHS in 1948, were among the honored celebrants. For each reunion, Jack fires-up his antique 1947 International Farmall Tractor, and loads it with bales of hay for his classmates to sit and stand upon as they gleefully ride down Main Street in the BHS Homecoming Parade.

In September of 1995, Jack decided to slow down a bit. He sold his three clinics in South Barrington, Cary, and Lake Barrington. "When I sold the clinics, people thought I had retired, but when I sold them, it meant I actually had more time to treat animals instead of being buried under ever-present piles of paper work. Selling the hospitals also benefited the customers, providing lower-prices, specialized equipment, and longer hours."

But now, after 40 years of continuous service to animals and their owners, Dr. Jack Noyes has fully retired. He spends winters with his wife and other Barrington snow-birds in Naples, Florida, golfing, boating, and fishing. But come spring, Jack and Jinny return to Barrington where their son, Billy, and daughter, Mimi, as well as their grandchildren live.

"Being a veterinarian has been a rewarding profession for me and for my family. Now that Jinny and I have seven grandchildren, I'm hoping one of them will get "bitten by the bug" to work with animals like I did. Perhaps, one of them will even go on to become a veterinarian. That would bring my story full circle, wouldn't it?"

Pets have been treated for over 50 years at the clinic named after veterinarian Dr. Jack Noyes, who is now retired.

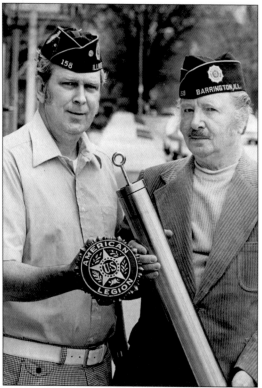

Jack Noyes served on the Board of Education in Barrington for several terms. He was a member of the committee that oversaw the planning and construction of the unique Barrington Middle School, which opened its doors to students in January 1966. Today, there are two middle schools in Barrington.

Ray Tourville and Commander Ray Novak of Barrington American Legion Post 158 insert a time capsule in the war memorial cannon at Evergreen Cemetery in the annual Memorial Day ceremonies on May 30, 1978. "The capsule will be filled with memorabilia whose purpose is to communicate to those yet unborn citizens that the American Legion is an organization dedicated to our nation, not only during war, but during peace as well," said Ray. (Photo courtesy of Ray and Marlene Tourville.)

V.

Ray Tourville

Americans still recognize barbershops with their candy-striped poles as a national symbol, but for the past four decades, the numbers of these neighborhood-based haircutting businesses have slowly dwindled. Ray Tourville, Barrington's barber for more than 40 years, is part of a dying profession that boasts of a long and rich history. He is a practitioner of an ancient and revered art.

Sources document that razors existed during the Bronze Age and that Alexander the Great ordered his Macedonian soldiers to shave regularly so their enemies could not grab their beards as handles in combat. Historians wrote that shops in Athens and Rome were hubs of boisterous and colorful conversation. In fact, most Romans spent several hours each day being steamed, scraped, bathed, trimmed, shaved, oiled, massaged, perfumed, and manicured. Barbering spread from Rome north, east, and west. In the 10th century, Arab barbers wandered the streets wearing belts and hooks from which dangled their tools: razors, scissors, water bottles, honing stones, and basins. Hearing these sounds, men gathered along the sides of roadways to wait for a haircut or shave.

Until 1745, barbers were also surgeons. Mic Hunter, in *The American Barbershop,* writes that "the combined services of haircare and surgery became so intertwined that when one referred to someone as a barber, it was understood to be short for barber-surgeon." After heated debate in Parliament, England's King George separated barbers and surgeons into two professions. Those who went with the surgeons' group were restricted to blood-letting, tooth-pulling, and use of herbal treatments. Barbers continued to cut hair, trim beards, and shave faces. When barbers stopped wandering the streets and moved indoors, barbershops reassumed their role as clearinghouses of local news and idle chatter. But as the 21st century begins, barber shops and their familiar poles with red and white spirals may become relics themselves.

Over 6-feet tall, clean-cut, and wearing silver wire-rimmed glasses, Ray Tourville remains one of Barrington's traditional barbers. He was born June 7, 1930, in Elmont, Missouri, population 300. The town consisted of a grocery store, gas station, and little else. People

Tourville, like the barber's striped pole, is an icon of the ancient profession that has been the center of classical operas such as Rossini's The Barber of Seville *and Mozart's* Marriage of Figaro.

lived along a narrow stretch of a 2-lane highway. Families relied on themselves, rarely getting together for children to play with each other.

When Ray turned four, his father died of tuberculosis, leaving his mother with the responsibility of raising three small boys. She took the two oldest and moved to nearby Sullivan where she found an apartment and worked at a local shoe factory. Ray lived with his grandparents in Elmont during the week and traveled to Sullivan on weekends to be with his mother and brothers. Ray's grandparents' home lacked electricity and running water, but young Ray never knew they were poor.

Ray's mother eventually married her brother-in-law, allowing Ray to move to Sullivan permanently. He liked school, especially being able to play with kids regularly. He recalls that in elementary school, "We had recess twice a day and enjoyed games of leap frog, mumbly-peg, and red-light/green-light. And, if some kid had a knife and marbles, we challenged each other to games of round ring/square ring and the teachers supervised our tournaments."

Third grade was a turning point in Ray's life. With 65 kids in the class, the principal divided the class into two groups: one group to go on, the other group to be held back. Ray was left behind. "What a break for me. That extra year let me mature, so when I entered high school, I was taller and stronger than other boys. This enabled me to play on

the basketball team all four years."

In his senior year of high school, a short, shy, slim young lady entered Sullivan as a sophomore. Marlene Du Chesne's family came to Missouri from Des Plaines, Illinois. She and Ray became sweethearts, but their relationship languished at the end of the year when Marlene moved to Barrington with her family so that her father could assist his mother and step-father in running a Standard Oil gas station on Northwest Highway.

After graduation, a year later, Ray moved to Barrington and got a job so he could be near Marlene. One year later, she graduated from Barrington High School and they were married on October 28, 1950. They lived in a trailer home on Miller Road for three months and then moved into the village where they have lived to this day.

Ray joined the Air National Guard out of O'Hare, and the young couple were separated by Ray's call to duty on September 1, 1951, by the U.S. Air Force. First, he was sent to Biloxi, Mississippi, for radar training, then to New Hampshire for additional training, and to Oak Ridge, Tennessee, when the Korean conflict escalated. Ray was sent to Tennessee to monitor incoming and outgoing aircraft. In 1943, Oak Ridge developed as a secret village in a valley of the Smoky Mountains. The importance of the site became clear on August 6, 1945, when an atomic bomb fell on Hiroshima, Japan. Fuel for the bomb had been extracted at Oak Ridge. In the 1950s, when the Cold War erupted, concern about the safety of the Oak Ridge complex received renewed attention from the U.S. military, which once again established a strong presence in the area.

Ray Tourville's high school graduation photo, May 1949. After finishing school, Ray moved to Barrington to be near Marlene. After Ray's stint in the Army, the couple applied for the GI bill and Ray enrolled at Moler Barber School.

Ray, age four, and his beloved cat, Snow, have their picture taken sitting in the family garden.

"Sitting in front of a monitor, staring at a screen, and watching radar scans was tedious work," said Ray. "We had one hour on and one hour off. Pay was $30 a month and by 1952, I had a wife and child to support. To supplement my paycheck, I volunteered for KP and earned an extra $10 per day. But the 16 to 17 hour stints quickly became exhausting."

Ray was honorably discharged from the U.S. Air Force on August 31, 1953, and returned to Barrington. He began working as a sales representative for an office supply firm in Elgin but found it wasn't for him. With a wife and child to support, and a job he didn't like, Ray and Marlene talked about what would be a suitable way for Ray to earn a living.

He had always wanted to be a pharmacist and had worked in a pharmacy in Missouri during his high school years—but becoming a pharmacist would take five years. An alternative plan would be for him to go to barber school, which required only one year to complete. The Tourvilles applied for a GI Bill loan, and Ray enrolled in the famous Moler Barber School in Chicago, which had been in business since 1893. The course of study required 1500 hours of classes. He studied science, anatomy, diseases, cosmetics, and the history of the barbering profession. "We also gave haircuts. The school was in an area where many homeless men lived. They would wander into the shop covered with dirt and debris. Our task was to remove the grit from their faces and necks, shampoo and cut their hair, and trim their beards *gratis*. Believe me— that was very good practice."

Marlene became the bread winner. Her job as secretary to Herb Walbaum at Barrington Realty for five years enabled Ray to attend Moler. His day began by delivering morning newspapers for Ed Hoggins at the Barrington News Agency. He then took the train to

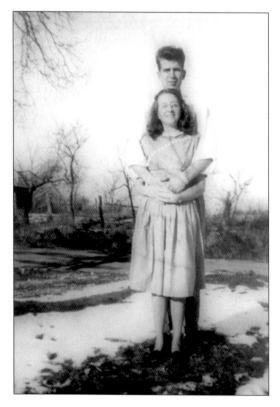

Ray Tourville and Marlene Du Chesne were high school sweethearts. This photo was taken in 1947 in Sullivan, Missouri, where Ray attended high school and the couple courted. After graduation, Ray moved to Barrington to be near Marlene. Soon after Marlene graduated from Barrington High School, the couple was married. Two of their children still live in the area, and another child lives with her family in Switzerland. When the Swiss flag flies from the Tourville flagpole, that's a signal that Swiss visitors are in town for awhile. (Photos courtesy of Ray and Marlene Tourville.)

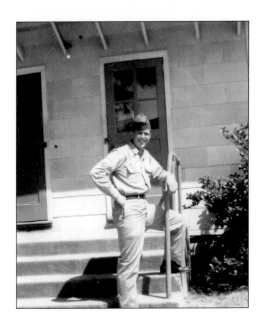

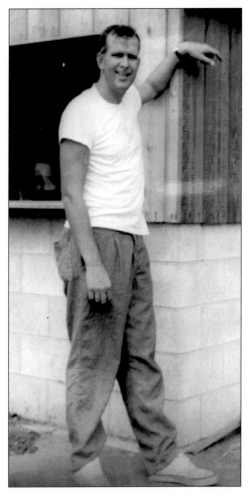

Above: *Ray poses in Biloxi, Mississippi, in 1951 at Keller Air Force Base. Ray joined the Air National Guard out of O'Hare and was called up shortly afterwards.*

Right: *Ray and Marlene lived in a trailer home on Miller Road for three months before moving into a home in the village where they live to this day. "This town has been good to my family and to me," says Ray. "It has been a perfect place to raise a family."*

Chicago and ended his day at home doing homework. The Tourville's efforts paid off. On January 6, 1957, Ray opened his first barber shop at 330 East Main Street. "I finally had my name in lights: Ray's Barber Shop." He then opened a 3-chair shop on Station Street before moving in 1961 to his present location at 113 South Cook Street.

By 1961, the Tourville family had grown to four wonderful children: Rick was born in 1952, Kim in 1957, Cindy in 1958, and Wendy in 1961. Putting aside nickels, dimes, and dollars, and obtaining a loan, the Tourvilles were pleased to purchase Ray's Barber Shop in 1978.

Barbering is an occupation to avoid if you have expensive tastes; it has not made the Tourvilles millionaires, but it paid off. "It was tough to make the decision to go to barber school, but I'm glad I made it, for barbering has provided my family with a nice home and a good life. On my income, raising four children in Barrington didn't allow us to purchase Corvettes, take ski vacations, or go out to dinner often, but I never had any regrets," said Ray.

Like most barbershops, Ray's is a potpourri of fragrances: witch hazel, Old Spice, Aqua-Velva, cigars, and pipe tobacco. They greet his customers when they enter the long, narrow

room. In the corner, near the plate-glass store front, is an antique barber pole. "Al de Stefano, my supply man for many years, purchased it for me from a barber in Cicero who was retiring. Al drove it here in his station wagon. It was one of the first electrified poles. It use to sit outside the shop, but it was vandalized so I brought it inside. I've repaired it several times and the parts are hard to come by, so sometimes, I make my own. Former Mayor Blanke begged me not to move the pole indoors because he said when his walking cane hit the base of the pole, he knew where he was in town."

While customers wait to get their hair cut, there are two end tables piled high with *Reader's Digest, Sports Illustrated, Field and Stream,* and *National Geographic* magazines, as well as paperbacks by Ken Follett and Dean Koontz to pass the time. The walls of the shop are lined with black and white and colored photos taken over the decades of children before and after their first haircuts. In addition to being treated to a photo-op, each little, first-time customer, when his haircut is completed, receives a parchment which reads "Certificate of Manhood." "Smiling parents scoop up locks of hair and take them home to be framed or placed for posterity in baby books. There are several photos of three generations to whom I gave first haircuts," said Ray.

Pictures of Ray's family and a needlepoint with a barbershop storefront motif made for him by his daughter, Cindy, also adorn the walls. Ray's affection for Barrington is evident in the two large corkboards brimming full of newspaper accounts of Barrington High School sports teams and athletes. Customers are invited to read the articles. BHS graduate Danny Wilson's career as a catcher for the Seattle Mariners is followed throughout the

Left: *Waiting for his next customer, Ray browses through* The American Barber *by Mic Hunter. Ray's shop and others like it are a dying breed. It was only by sheer will and loyal customers that Ray managed to stay in business over the years.*

Below: *The local press announces the opening of Ray's Barber Shop. "I finally had my name in lights," chuckles Ray. (Ad courtesy of Ray and Marlene Tourville.)*

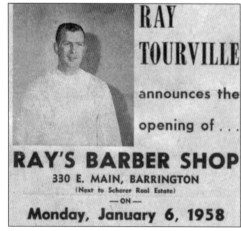

RAY TOURVILLE

announces the

opening of . . .

RAY'S BARBER SHOP
330 E. MAIN, BARRINGTON
(Next to Scherer Real Estate)
— ON —
Monday, January 6, 1958

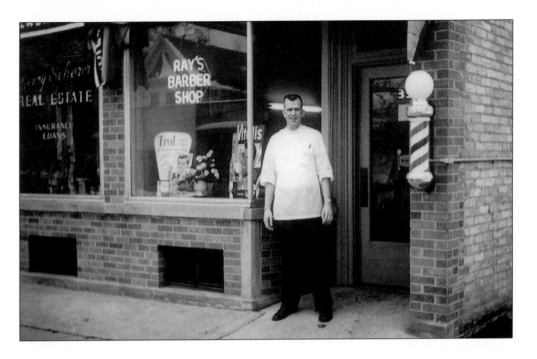

Ray Tourville pauses outside his barbershop. Meanwhile, customers inside find a world filled with the familiar smell of after-shave lotion and a floor strewn with hair clippings, a spot that served as an oasis for good conversation for "regular guys." (Photo courtesy of Ray and Marlene Tourville.)

baseball season—it's a focal point on the bulletin board.

Like other barbers nationwide, Ray has watched his profession change during his tenure. Of the 180,600 licensed barbers in the U.S., 50% are 60 or older. Many of them operate one-chair shops, so when they go, the shops will go with them. Today, there are fewer and fewer graduates of barber schools. Instead, men and women are becoming beauticians or stylists. "What's the difference between a beautician and a barber?" Ray asked. "Well, a beautician makes more per cut than a barber, that's the only real difference. After all, much of the training is identical."

The late fifties and early sixties were good times for barbers. Gentlemen had their hair cut every two weeks and short hair styles were popular. Men wore hair cuts with names like Flat Tops, DAs, and Princetons, but the pattern changed in the late 1960s. The invasion of the Beatles— with their mop-top hairstyle— began a trend, and men let their hair grow longer and longer. "Older customers objected to the longer hair and spoke of it as being indicative of the ruination of America," said Ray. Their attitude reflected billboards seen around the country which read: 'Beautify America: Get a haircut.' "Hair length divided families. Parents wanted their sons to have short hair, while their sons wanted to have long hair. I lost customers on both sides of the fence during those years."

But Ray's memories of the sixties are upbeat. He fondly recalls that Barrington celebrated its centennial and that presidential candidate John Fitzgerald Kennedy came to town. In the fall of 1960, George "Barney" Ross invited his friend JFK to Barrington. Barney had been a member of the crew aboard Kennedy's famous P.T. boat and the two men had kept in touch since their war years. Kennedy's staff arranged for the charismatic senator to

Since joining the American Legion, Ray has served in a variety of ways, including being the post's pastor. Here, Ray stands before the permanent "Wall of Fame" at Barrington Middle School-Station Campus. Each year, honor students each select one vet to recognize for "service to America." The students create "bricks" for each honoree. On the brick are the vets' name, the dates and campaign in which they served, and an American symbol. This photo was taken on November 11, 2001, at BMS. Above the wall a sign reads "Students of BMS-Station Campus honor the men and women who served their country to preserve democracy and freedom." Ray is a member of American Legion Post 158. (Photo courtesy of Ray and Marlene Tourville.)

campaign in Illinois with a focus on Chicago and the northwest suburbs, and he came to Barrington. While he was in town, Kennedy spoke to a large crowd gathered at the high school. He was greeted by many well-wishers and a sea of bobbing, *Nixon-For-President*, red-white-and-blue posters.

"Coming into Barrington's Republican stronghold took a lot of guts, but it also demonstrated his affection for his friend, Barney." After Kennedy defeated Nixon, talk about JFK's Barrington visit became a hot topic of discussion among many of Ray's customers, some of whom feared that the nation would become Catholic.

During Barrington's centennial in 1965, many townsmen grew beards. One part of the celebration was a contest to determine whose beard was longest, thickest, best groomed, or most unruly. Ray won one of the categories and his prize was a free haircut at another shop in town. "That was a great chance to see how another barber ran his shop even though it was a bit ironic."

By the 1970s, the length of a man's hair became a political statement rather than a fashion statement. Long hair was viewed as a rejection of America's participation in Vietnam. "My customers considered men wearing long hair unpatriotic. Others complained that these young people looked as if they hadn't washed their hair for weeks or months. Fortunately for me, I had a loyal following and my business wasn't hurt. But there were plenty of shops across the country that had to close their doors."

It wasn't the decline of barbershops that devastated Ray and Marlene's world: it was when Ray was suddenly stricken with Guillian-Barré Syndrome (GBS) in 1988. The disease progressed rapidly. Ray felt "pins and needles pricking his fingers," then there was numbness in his toes, and within days, he was completely paralyzed.

At the onset of the disease, a doctor told Ray that the "tingling sensation" he felt in his limbs was the result of a circulation disorder. The doctor encouraged Ray to "go home and walk it off." But his condition continued to deteriorate. Worried and confused, he called his friend Dr. Joe Micheletti and described his symptoms. Dr. Micheletti advised Ray to get

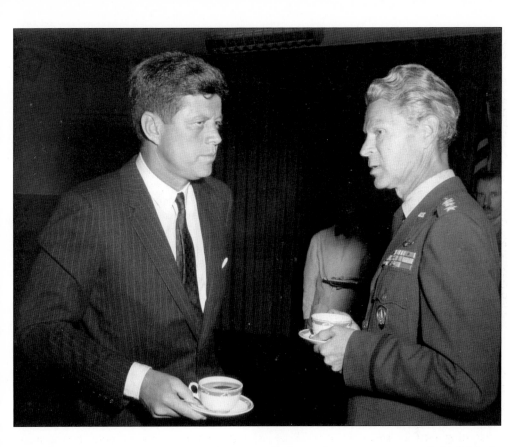

In the 1960, a young, enthusiastic, Senator John F. Kennedy flew to Illinois to garner support for his bid for the Oval Office. JFK felt confident that Daley could give him Chicago, but wasn't sure if he could cut into Nixon's lead in the north and south of the city, so Kennedy toured these regions. He came by motorcade to Barrington High School and spoke to a less than enthusiastic Republican audience. However, when the votes were tallied, Kennedy carried the state. After his election, Kennedy flew to Europe to speak with America's allies. Here, he chats with General Lauris Norstad, the supreme commander in Europe at the Supreme Headquarters Allied Powers Europe (SHAPE) Headquarters just outside Paris, in June of 1961. (Photo courtesy of retired Colonel Ted Chesney who stood to the left of the two leaders during the proceedings.)

to Sherman Hospital immediately. The neurosurgeon who examined Ray told the Tourvilles that he was 98% certain that Ray had GBS or "French Polio." A test of Ray's spinal fluids confirmed the diagnosis. Ray remained in critical care for three weeks while his life hung in the balance. Five percent of all GBS patients die, others are left physically impaired, and no one ever makes a complete recovery.

Marlene moved into Ray's hospital room. GBS often damages the patient's muscles that control speech, swallowing, and breathing. Without 24-hour supervision, patients can suffocate. Marlene became Ray's lifeline, supervising his every breath. Meanwhile, she watched him grow weaker and weaker. She watched him take pain-killers that caused him to hallucinate; she watched him become totally dependent on his care-givers. It was a nightmare for both of them. When the disease finally ran its course, Ray moved to Marianjoy Rehabilitation Center in Wheaton. Here, he faced the greatest challenge of his

life—recovery and rehabilitation. At the rehab center, Ray relearned how to talk, sit up, move his arms and legs, and even shave himself.

Each step along the way was excruciating. Relearning to use his limbs took every bit of his energy and after a session, his body was soaking wet. The exercises were frustrating, humbling, and depressing. Living with pain became the norm. Fighting against the debilitating effects of GBS became the Tourville's crusade.

Throughout his ordeal, Ray never wallowed in self-pity. He looked around and saw others more impaired than he, and decided to do what he could to ease their suffering. He took a liking to Bob who had become a quadriplegic after a diving accident. The men spent hours talking about sports and life as they sat side by side in their wheelchairs in the rehab's solarium.

One day, Bob said to Ray, "I need a haircut. My hair is crawling down my back, driving me crazy."

"I'll cut your hair," said Ray, "Remember; I'm a barber." But to cut Bob's hair, Ray had to relearn how to hold and use the tools of his profession. "At the beginning, I couldn't even squeeze the scissors. My fingers felt swollen and awkward in the loops. Opening and closing the shears was tedious and painful. My fingers wouldn't obey my mental commands. With lots of effort, time, and patience, I succeeded in cutting Bob's hair using a pair of clippers and a comb. After the haircut, he thanked me and later, the two of us shared some good laughs over that first haircut." Ray kept in touch with Bob after Ray left the Marianjoy Rehabilitation Center.

Throughout Ray's illness and recovery, his barbershop closed. After a full year with no

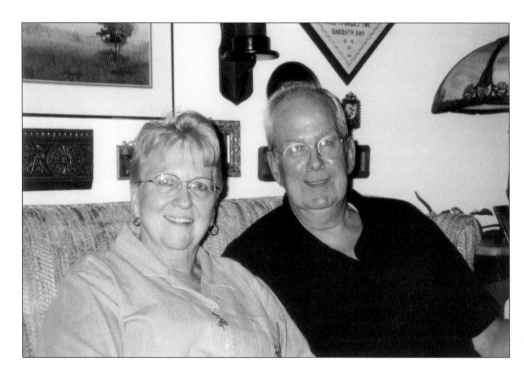

Ray and Marlene Tourville celebrated 50 years of marriage on October 22, 2000. They are surrounded by the love of their children and grandchildren. "They make every sacrifice we've made worthwhile."

Boys used to have their hair cut in special chairs. Some of them, however, were just miniature versions of adult chairs. Use of bribery was commonplace —at the end of a haircut, a sucker worked best, especially when tears were involved. Red-headed Nicholas Tarnofsky sits on dad Bob's lap to await a first haircut at Ray's Barbershop. Nicholas represents the third generation in his family to get his hair cut at Ray's. His grandfather, Don Istvan, and his uncle, Jay Istvan, were frequent customers of Ray Tourville.

income, he returned to his shop and rebuilt his clientele, working as much as his weakened body allowed. "I still have some numbness in my legs, and I think I walk funny now, but at least my legs work."

Over the years, Ray has had many interesting experiences as a barber. His youngest client was only four days old. Right after the baby was born, his dad called Ray to make an appointment for the child to get his hair cut. "I thought the new father was just bragging about his son's hair. But when the dad carried his infant into my shop, I realized that the boy truly needed a haircut. His hair was thick and black, and so long it was getting into his eyes, ears, and mouth. The father held the baby in the crooks of his arms while I cut its hair. Imagine the trust that father put into my hands as the child's hair fell to the floor while I clipped away."

Is Ray ready to retire? "Yes and no. Not being able to work in 1988 wiped out my immediate plans for retirement. But that's OK. Cutting hair is what I do and if I quit, I'd miss my customers."

All through his life, Ray has kept a commitment not only to his profession, but also to Barrington. He's been a member of American Legion Post 158 since he was discharged from service and has served as its commander. Currently, he is the post's chaplain. He is proud to be part of the American Legion baseball program, which donates thousands of dollars in scholarship money every year to deserving athletes.

The Tourvilles frequently visit their children and grandchildren. "Being able to travel and see family in another country, another setting is grand." Tourville poses with four of his grandchildren outside Lenzburg Castle in Switzerland. Ray and Marlene are devoted to their nine grandchildren: seven boys and two girls. They include Jenny, Matt, Jeff, Gregory, Eric, Jakob, and Sabrina. Each time a grandchild turns ten, the Tourville's take the child to Gruyere, Switzerland, where their daughter lives with her family.

In the summer of 1999, Ray was honored at the 81st Annual Legion Convention held at the Rosemont Horizon Center when he was presented with the Chaplain's pin for service to the Legion. Over the years, he has helped raise funds for community causes by selling poppies at the train station and American flags in his shop.

Clients and friends alike know that Ray Tourville is a compassionate man. Don Istvan, a Barrington resident and long-time customer of Ray's, describes him as "a man who enjoys life and looks forward to what comes." Like many loyal clients, Don introduced his two grandsons, Nicholas and Scott, to Ray the Barber when it was time for the boys to get their first haircuts.

Ray and Marlene both attribute his miraculous recovery from three life-threatening diseases—GBS, prostate cancer, and open heart surgery—to countless prayers offered by family and friends, as well as the spiritual strength given them by Gene Nyman, their pastor at the Community Church of Barrington.

The Tourvilles celebrated 50 years of marriage in October, 2000. Two of their grown children live nearby and one daughter lives in Switzerland with her family. The Tourvilles frequently visit, call, and exchange letters with their children and grandchildren.

After 45 years in the business, Ray Tourville, the Barber, still maintains that nothing beats the joy of giving "a little guy his first haircut." He recently set down his scissors to retire after many years of making stylish improvements to the hair of men and boys in Barrington.

VI.

Bill Rose

Bill Rose sits in a large, leather chair in his sumptuous rosewood office, surrounded by models of his passions: airplanes and old-fashioned paddleboats. There are also countless awards and numerous family photos. The room belies Bill's struggle to reach his standard of living. William R. Rose, or Bill Rose, as his friends know him, is Barrington's own Horatio Alger. When he accepted a job to work for his father's meat packing business near the Chicago Stock Yards in 1949, he had no idea how vital that decision would be for him and for the future of the Rose Packing Company. Bill does not believe in fate, but he believes life brings us to crossroads and the paths we pick alter our lives forever.

Bill began the interview by saying, "I started working on a full-time basis at Rose Packing Company shortly after getting married. For the first six months, I drove from Park Ridge to the Green Street plant. I had no clue that my father was about to sell the business for $150,000, and I had no clue that Rose Packing was losing between $1,000 and $2,000 a week. Rumors of the impending sale spread through the company's 200 employees. Mr. Tabson, the plant supervisor and reluctant modernizer, resigned after being diagnosed with a brain tumor.

Walter Gleason was one of my dad's most loyal workers. Neither of us was fully aware of Rose Packing Company's dire financial condition. The idea of selling the business came as a shock to both of us. But after several conversations with my dad, we convinced him to give us 12 months to try to turn the firm around. Walter and I knew that Dad's meat packing business needed to be run more efficiently. We also knew this would happen only if Walter became plant superintendent and I became the engineer-of-change. We committed ourselves to saving Dad's company. During our 'probationary period,' Walter and I spent every waking hour doing just that. We supervised a complete overhaul of Rose Packing Company from the production plant to the corporate office. It took us awhile, but we eventually returned Grandpa Louis Rose's meat packing account book to the black."

William R. Rose was born to William A. Rose and Adalyn Kitson Clinkenbeard Rose on February 20, 1927, in Corry, Pennsylvania. An only child, W.R.'s family moved to New York

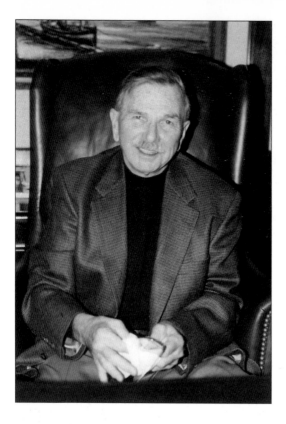

Bill Rose is surrounded by models and pictures of his hobbies, businesses, and family in his South Barrington headquarters. A multimillionaire, he customized his own way of life and business.

City when he was seven. For one year, he attended a small, private school which was down the street from the Paris Hotel where the Roses lived. Bill admits that he was not a good student and that he preferred to learn hands-on. Every day after school he enjoyed riding the city buses around New York. He traveled from the theater district to the dockyards, passing time until his parents came home from work. "My dad rarely took time off," Bill recalled with a bit of nostalgia in his eyes, "a habit I admit I also developed."

"When I was little, I stuttered at lot. When Grandmother Clinkenbeard came to visit, she and my mother would go to Chautauqua and participate in elocution contests. When they came home, my grandmother put five marbles in my mouth and said, 'Speak out! Speak out!' She left her mark on my life. She made me know that I could face a problem head-on and solve it. I just had to put my mind and will to the task." Bill's speech is now flawless.

In 1934, the W.A. Roses moved to 544 Sheridan Road in Evanston. "Shortly after that, my grandfather, Louis Rose, the founder of Rose Packing, died. Dad and his brother were now in charge.

One day, when I was in the fourth grade, I went to nearby Calvary Cemetery. Playing around, I tipped over a number of tombstones and uncovered 52 garter snakes. I put them in a box and planned to take them to school to give to my science teacher. But while on the school bus, a girl sitting near me kept asking, 'What's in the box?' What's in the box?' So I opened it and poured the snakes all over her head. For awhile after that, I was nicknamed 'Snake Boy'. Is it any wonder that I was always being sent off to another school? My mom and dad eventually enrolled me in Valley Forge Military Academy in Wayne, Pennsylvania. This seemed the 'perfect' school for me. I still have friends from my years at

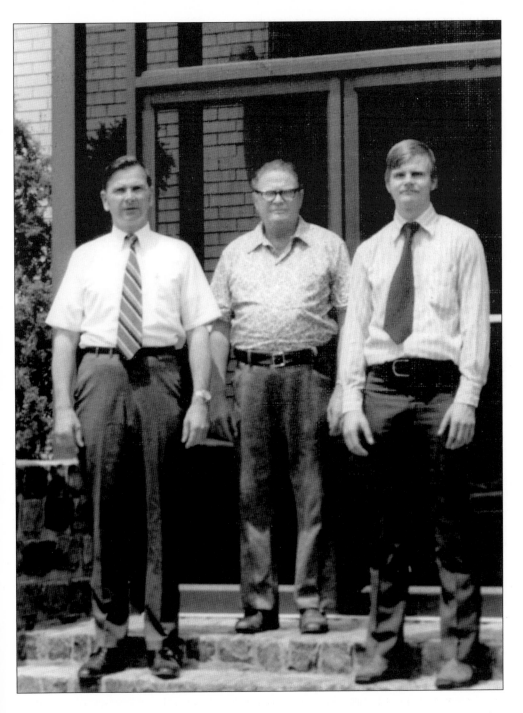

Three generations of the Roses are pictured here, from left to right: William Richard Rose, William Arthur Rose, and Peter W. Rose. They stand in front of the corporate headquarters located just off the Northwest Tollway and along Route 59 in South Barrington. Bill's grandfather, Louis Arthur, worked for Armour & Co. before starting his own business. Today, Bill Rose's empire stretches way beyond the meat packing business. (Photo courtesy of Rose Family.)

Eighteen-month-old Bill Rose sits in his infant scooter at home in Buffalo, New York. Even at this tender young age, it was apparent that Bill had a mind of his own.

Valley Forge, and I gave the commencement address on the occasion of the 50th anniversary of my class's graduation. That was quite an honor for a reluctant scholar.

Right after finishing at Valley Forge, on February 20, 1945, and shortly before my 18th birthday, I enlisted in the Marine Corps. In fact, I planned to enlist in the same building, the old Philadelphia post office, in which my father joined when he was the same age. While in the Marines, I began saving money so I could purchase land. First, I bought an acre or two, but soon I owned 60 acres deep in the woods of Winchester, Wisconsin. Whenever I had any extra money, usually earned from my participation in Saturday night boxing matches, I increased my holdings. I planned to build a cabin on the property and live like Thoreau, far from the noise and bustle of city living.

But life provided me with a second crossroad. After I obtained the highest test scores in my platoon, the Marines wanted to send me to Officer Candidate School. When they told me that I would have to serve another four years beyond my wartime requirements, I declined their invitation. By the spring of 1946, I was serving at Guantanamo Bay in Cuba. In the fall, I was discharged. I bought a Jeep, a cement mixer, a 36-inch buzz saw, and headed for Wisconsin. I visited my family briefly, and my parents were not too pleased with my leaving to build a cabin in Wisconsin just after arriving home from my tour of duty.

Problems at Rose Packing were at a peak between my dad and his brother, Greg, who was the president at the time and in charge of the company's Danville, Illinois, slaughterhouse. In the fall of 1947, when I returned from my cabin to take an entrance exam at Northwestern Technical School, their partnership finally dissolved.

Rose Packing Company Corporate Headquarters moved its headquarters to South Barrington in the late 1950s. The Georgian style building was completed in 1973. Over the years, Bill Rose parlayed a succession of personal hobbies into a series of far-reaching businesses. Among Rose's enterprises, in addition to the meat packing operation, are cold storage facilities, land developments, the Country Store, a restaurant and brew pub, marinas in Florida, and a farm with an enormous landing strip near Marengo, Illinois. Bill Rose salvaged his grandfather's business and created a whole new empire in the process. The Country Store opened in 1975, and has been renovated several times since.

Bill Rose believes that life is about "crossroads." The path people choose to take when they come to a fork in the road can determine their success or failure. He seems to have taken many "right" roads over the past 70-plus years. "People say I was smart to use barns," said Bill. He has gathered many and put them to use on the Rose complex site. "I wasn't smart—I just used what was around me," said an always pragmatic Bill.

During this same period, I reached my third crossroad: I met Barbara Blanchard at a local riding stable. She was a copy editor for an advertising agency in Chicago. On June 19, 1948, we married. My parents hosted our wedding reception on the lawn of their Evanston home on Ridgeway Avenue. Soon after the ceremony, I took my bride to the cabin in Winchester's backwoods. Barbara wasn't too fond of the primitive conditions of our cabin, nor of her role as cook and housekeeper. She was a city girl, raised on a life of travel, convent schools, and French culture. Her adjustment to our crude homestead was none too easy for Barbara.

That fall, we traveled to Houghton in Michigan's Upper Peninsula where I wanted to attend the Technological College. Barb became pregnant, however, and when she was about to deliver our first child, she wanted to be close to Evanston Hospital. She had been born there, and her mother worked there as a volunteer. After returning to Evanston, I never went back to finish my schooling. Instead, I was hired by Rose Packing."

Bill's son Pete said, "When my dad teamed up with Walter Gleason, their relationship looked like an Abbott and Costello movie. If Walter screamed at a worker, my dad would put his arm around the worker to assure the 'victim' that he or she was a valued employee in the Rose family operation, and that Walter was just letting off steam. These guys were like good cop, bad cop. But, together, they produced hurricane-strength gales of change. They were determined to reconstruct Grandpa Rose's packing company bolt by bolt, order by order, day by day."

Gleason's son-in-law, Dwight Stiehl, recalled, "Hard work was interspersed with good

Bill Rose's luxuriant rose-wood office is filled with ultra-modern technological "gadgets" which provide Bill with the means to keep a pulse on his numerous businesses. The elegant room puts visitors at ease in the presence of one so accomplished.

The walls of Bill's South Barrington office are lined with shelves dedicated to his hobbies: paddle-boats, antique airplanes, flying, and politics. Many items also reflect Bill's time spent in the Marine Corps, and his interest in his Scottish heritage. His apparent affinity for family photos illustrates his primary interest.

times. Walter and W.R. built a go-cart at the plant. They took it to Walter's house in Crete, and the Rose and Gleason kids had hilarious times riding up and down the hilly terrain."

"When Walter died, it was an incredible loss to my dad. He lost part of himself," said Pete.

"I still miss him," Bill added. "During the early fifties, some of our solutions to problems brought on new problems.

The forklift trucks, for example, proved too heavy for the elevators, and they could not be used between floors. My dream was to construct a single-story building that would allow us to be more efficient and to reduce the number of workers.

Although my father had grave doubts, he allowed me to pursue the project, certain that I would fail in my search. I think he was just humoring me. Dad did not believe we should own any buildings; he doubted anyone would construct a single-story building on the scale I wanted, and he knew we did not have the credit history to enable us to finance the project. Then, I met Dick Loreno, a broker and salesman with one of Chicago's largest real estate agencies, Arthur Rubloff and Company. Dick took me to an industrial park called the Clearing Industrial District near Midway Airport.

After several conversations, Jim Rice and his staff agreed to build our plant. It was not the 100,000 square-foot plant I dreamed of, but a more modest one of 65,000 feet. I was only 29 at the time, and I naively set about designing the site, making a model of it out of red, yellow, and blue Legos.

In 1957, we took possession of our new plant at 4900 South Major Street in Stickney, Illinois. We couldn't afford professional movers, so we used our employees as movers. I used chalk on the floor of the new plant to mark the location for each machine. Workers

Front entrance to the Rose Plant at 4900 South Major in Chicago, Illinois. (Photos on this and the next page courtesy of Rose Family.)

hung the electrical wires and piping from the ceiling, and one year after being in the new facility, Rose Packing cleared $100,000 after taxes. In just five years, I paid Clearing Industrial District the cost of the building. After the first three years of reorganization, Rose Packing doubled its plant production, decreased its work force by 50%, and reduced the number of times a product was handled from 15 to only 3.

I felt like I was a man watching the beginning of the Industrial Age," says Bill. "I was amazed that a man like me, with a minimal college education, could completely transform our archaic company into the efficient, production-oriented company that it became.

When our office manager/ accountant took flight in 1956, I hired Winkle Lee and Howard Liu, both from Hong Kong, to keep our books. They did their figures on abacuses and were 50% faster than our staff working on their comptometers, the precursors of computers.

Our Major Street building drew wide press coverage when the *National Provisionor* devoted six pages and twenty-six photos to our super-modern facility. Within two years, we expanded the building, and we haven't stopped.

In 1957, I began looking for a new homesite for my family. I looked all over the area, traveling first by air, then by land. Late in the year, I bought Ned Twertal's home on Mundhank Road. It had been the George Fairweather Farm, and I paid $49,000 for 20 acres and a small farmhouse. We moved in during the winter of 1958.

The biggest piece of luck I had, the biggest crossroad in my economic life, was not my being hired by Rose Packing Company; it was the move to Barrington, to that little farm."

About the time the Roses moved to Barrington, their neighbors were selling off their land. "Over a period of years, with and without partners, I bought more than 1,000 acres,

Pictured here is the pork sausage grinding room at the Rose Packing Company's Chicago Facility.

Workers are busy in the pork sausage stuffing room of the plant. Quality control and rigid adherence to cleanliness characterize all areas of the operation. Over the course of his tenure, Bill has patented the design of countless pieces of equipment that have made the processing more and more efficient. (Photos courtesy of Rose Family.)

The Millrose Inn Restaurant and Brew Pub as seen from above. The Country Store is located adjacent to the restaurant and is accessible from inside the dining facility. (Photo courtesy of Rose Family.)

500 of which were contiguous to my original piece."

Maggie Cosgrove, now Vice President of Rose Packing and former secretary to Bill said, "At that time, all was not peaceful and prosperous at the packing company. Bill's dad was against everything his son tried to do. He didn't like new ways of doing things. He didn't want anything changed, and Bill always had to argue with him about any new idea he was considering. Only after Bill put the new equipment or project in place, and W.A. Rose saw its importance to the packing company, did he agree that Bill's idea was right. With Bill's ability to plan for the future, the company continued to grow."

Bill continued, "We added a packing department, additional loading docks, a penthouse conference room above the dock area, a helicopter pad, a machine shop, a guard house, and an accumulator or storage building. We also purchased an additional 65,000 square-foot warehouse on Fifty-first Street, one block from the plant, for dry storage. It held boxes, bags, and castings; a garbage compactor, and a bailing recycler for cardboard. The new building also had a delivery dock, truck repair shop, laundry room, cafeteria, and office."

While the Rose Packing Company was on the move, so were developers in South Barrington. Fearing the kind of high-density housing the developers had in mind, Bill organized a committee consisting of W.R. Rose, Fred T. Kramer, Bill Brough, Laura Witt, Hans Seegers, and Ferris Gaskol. They hired an attorney, Andy Dallstream, and decided to form a village before others attempted the same move.

With the help of some savvy people and precise timing, the group managed to file their petition first, and their plan was accepted by the court. On December 12, 1959, a general election was held to establish the first South Barrington Board of Trustees and to elect a

Bill donated half-a-million dollars to Unit District 220 to assist in the construction of the Barbara Rose Elementary School located on Penny Road. The school is nestled among nearby opulent estates and open land. Barbara Rose served on the elementary, high school, and unit district school boards. "The school is a tribute to one who gave so much to so many," Bill said. "I get a kick each time I ride by the school. Barbara would have been pleased with it all."

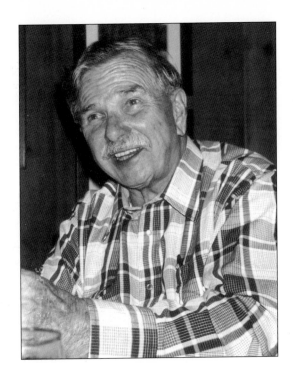

Bill Rose holds court during dinner, telling jokes and puns to a delighted audience of family and friends.

village president. Forty-seven voted for and six voted against the slate. Fred T. Kramer became the first Village President and Gene Scully was the first Village Clerk. Also elected to the Board of Trustees were Bill Brough, Laura Witt, Al Weiman, Hans Seegers, and Art Hogfelt.

"After numerous annexations, court appearances, over $100,000 in legal fees, and a successful fight to fend off the installation of an atomic accelerator, the Village of South Barrington endures," said Bill.

Warren Fuller, former Mayor of South Barrington and Bill's attorney, said, "Bill seems to thrive on challenges. He's a proactive visionary."

"When we first moved our corporate headquarters to Barrington," Bill said, "there were no restaurants in the area. We served meals on the second floor of our offices, and I hired the wife of the Chief of Police to prepare lunch for our employees, who also wanted to buy company products at a discount, so we opened a kind of 'chicken coop' out back where we sold hams and other Rose products.

One day, I looked out the office window, and there were 50 people standing in line in the rain waiting to get into the 'chicken coop.' So in 1975, we moved a barn from the former Magunson farm to a location next to our office and made a bigger, better 'coop': the Country Store.

By 1998, we had brought together six old barns to comprise the current Millrose complex, which now consists of a 700-seat restaurant, brewery pub, three banquet rooms, a luncheon patio, a sunset patio with a beer garden, the Rosewood Tavern, and the Country Store. In 1998, the *Restaurants and Institutions* magazine listed the Millrose as the 67th largest restaurant in the United States in sales volume. Since then, we have added 125 more seats."

When Bill's wife, Barbara, died in 1993, following several heart attacks and lung cancer, Bill donated money in her memory to Barrington School District 220 to build the Barbara

B. Rose School on a 30-acre site on Penny Road in South Barrington. The school was opened in the winter of 1999. Bill would like to see a middle school added to the Rose Campus in the not-too-distant future. Barbara also served as director for the Barrington Youth Service and the Family Service of South Lake County for many years.

"Life and death, success and failure, gains and losses make up the fabric of life," said Bill. "I am surrounded by a loving family consisting of my new wife, Myrt, my sons, Peter and Michael, daughter Susan, and their spouses and children. They represent the fifth generation of Roses. I hope that they will continue the dream of a great packing company that my great-grandfather Louis Arthur Rose had when he arrived in Chicago from North Dakota and started working for Armour & Company at the Back of the Yards."

"A century from now, the Rose Packing Company may not resemble anything it looks like today." Bill said. "I hope that it will continue to change with the times and continue to serve the community."

Looking backwards and into the future, Bill Rose sums up his philosophy: "It was the crossroads in my life that made all the difference. And you don't know until 10 or 20 years later what those crossroads were and if you made the right choices. People say I was smart to move out to Barrington with all this raw land. People say I was smart to use the barns. I wasn't smart; I just used what was around me. I have lived by the idea that if I can't stand on it, fly it, drive it, or eat it, I don't invest in it."

Leonardo da Vinci said of flight: "Once you have tasted flight, you will walk the earth with your eyes turned skyward. For there you have been and there you will return. Oh, wonderful bird. Oh, wonderful machine of nature, what you so effortlessly do man can copy with effort, with pain. But man too can fly. This I know."

Bill Rose's passion for flight matches da Vinci's passion to understand how birds could fly so freely.

The Rose Packing Company Plant stands at 4900 South Major Street in Chicago. Note the Rose Company logo on the side of the truck. (Photo courtesy of Rose Family.)

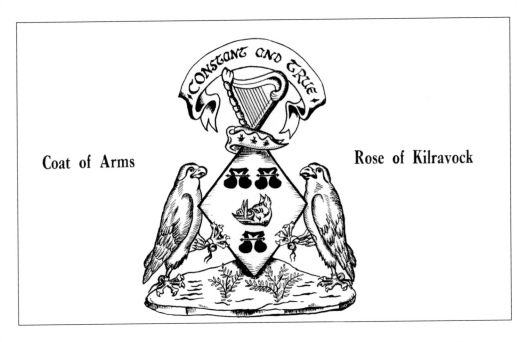

Coat of Arms **Rose of Kilravock**

Bill Rose earnestly explores his family's history. He has made several trips to, and stayed in, his ancestral home in northern Scotland. Current records reveal that the Rose clan emigrated to the British Isles during the Norman Conquest and settled in the Scottish region at the beginning of the 13th century. Here are sketches of the family coat of arms and Rose Castle of Kilravock. (Images courtesy of Rose Family.)

*Words of Wisdom from
William R. Rose

• **Investing**:

 If I can't stand on it, fly it, drive it, or eat it, I don't invest in it.

• **Philosophy**:

 I'm right 75% of the time and allow myself to be wrong 25% of the time. If a brain surgeon would believe that, then that wouldn't be a good philosophy.

• **First 50 years**:

 Lately, I feel like you spend the first 50 years climbing a hill and then you start down a toboggan slide. There are too many places to go and things to do.

• **Nepotism**:

 Unlike most corporations, we try to encourage nepotism so as to benefit the families involved as well as the company. If a person is being interviewed for a job at Rose, we ask if that person has any relatives working for Rose. Most do. If the senior relative of this clan—man or woman—doesn't recommend that person, we don't hire him or her. Rose would rather pay overtime to get the work done than to hire a bad employee. Both men and women have the same hourly wage and there are about equal numbers of each.

• **Formula for Survival in the Meat Business**:

 Rose Packing Company closes its business once a week. We quickly understand if we're making money or losing it. At the end of three or four weeks of losses, the following formula will guarantee survival. It will not guarantee you will become wealthy, but it will guarantee survival.

 It is as follows: At the end of the aforementioned number of weeks, you raise the prices overall to the customers by a modest amount equal to about $5,000 a week, and more important, you reduce the expenses by an equal amount. So, if you raise the prices $5,000 to $7,000 a week, you reduce your expenses in equal amounts per week. This gives you a swing of $10,000 to $15,000 a week to do business with. The important thing is, you do not rely entirely on destroying many of the ongoing programs you have in place to reduce expenses.

 As my father used to say, "In the meat business, you make money six months of the year and lose money six months of the year. The trick is to make more money during the six months you're making money than you're losing the other six months."

 Excerpted from A Brief History of Rose Packing Company and Its People: 75 Years, 1924-1999.

Compiled by Kay Schwerzler as told by Bill Rose.

VII.

Audrey Veath

Audrey Veath is a diminutive, always-smiling, gray-haired grandmother and unassuming hero who is helping to change lives in remote regions of Africa, Asia, and South America. Her red-brick village home is filled with colorful and varied Nativity scenes and Noah's Arks that she has been given or gathered from trips around the world. She also collects multi-hued quilts and bright Guatemalan textiles. She is a deeply religious, soft spoken, gentle person who is much admired by those who know her. These friends and acquaintances nominated and honored Audrey as one of the 1999 *Pioneer Press* Volunteers of the Year.

Audrey's Barrington roots are as deep as Lake Baikal. Her father, Walter Witte, was born here in 1901, and her mother, Bessie Thrun Witte, was born here in 1904, on a farm near Elgin. Audrey was born at home on Summit Street on February 16, 1933. She remembers Barrington as a "wonderful place" to be raised.

"When I was a little girl growing up here, everyone knew everyone. It was such a small town that all adults acted as every child's surrogate parents, and they would scold us or tell our parents if they saw us doing anything out of line.

In the winter, when we were kids, everyone in the neighborhood gathered at a designated site and went sledding down Summit Street. On warm, summer days we swung from cherry or oak trees in our back yards, and in the twilight hours, played games of Statues or Mother May I?"

Audrey attended Hough Street School from kindergarten through the first two years of high school. She then transferred to Barrington's new Main Street facility for her last two years. "It was a glorious time. We were so innocent, free, and protected."

It was during her high school years that Audrey began working after school at the Town Shoppe to earn spending money. Here she met her future husband, Wilbur "Nibs" Veath. She was so good at doing her job as a soda jerk, shelf-stocker, and counter-server, that on December 8, 1951, six months after she graduated from Barrington High School, she and Nibs were married, "because he didn't want his best employee to get away."

Audrey Veath subscribes to this ancient Chinese proverb: "Give me a fish, and I will eat for a day. Teach me to fish, and I will eat for the rest of my life." She is helping people in some of the most remote villages on the earth learn to feed themselves.

Nibs' family had owned the Town Shoppe since the early 1930s, and Audrey and Nibs bought it from his brother in 1957. The young couple worked 7 days a week, 10 to 16 hours per day. By night, the Veaths were dog-tired. "The long hours made us weary, but our customers made it worth getting up for in the morning," said Audrey. Before dawn, Nibs opened the store while Audrey fixed eight or more gallons of soup and baked half-a-dozen pies which she then carried to the store.

"Owning the Town Shoppe was a wonderful experience," she says. "It was a Ma and Pa operation, the kind that has all but vanished from the American landscape. Our children—Christy, Peggy, and Andy—worked in the store through their high school and college years. Nibs and I always knew where our kids were."

The Town Shoppe served as a hub where locals shared conversation over steamy cups of morning coffee before they boarded trains to go to their jobs in Chicago. Others came at lunchtime to eat bowls of homemade potato or vegetable soup, pieces of freshly baked lemon meringue or strawberry-rhubarb pies. Before the days of air conditioning, people gathered on warm summer evenings at the Town Shoppe to cool off with glasses of cold lime rickey or double-dip ice cream cones. The shop had a wonderful, elongated fountain counter that provided Barrington residents with a comfortable place to sit and chat before and after sports events at the high school. It drew them together to debate local and national politics and contributed to the camaraderie of the community.

"People came to the Shoppe regularly and built friendships with one another," said Audrey. "There was an unwritten code which required that anyone overhearing gossip at the shop was to leave what they heard behind when they left."

Celebrities like South Barrington's popular WGN disc jockey, Howard Miller; broadcaster Mel Belairs; and country western singer Bob Atcher came to the Town Shoppe to socialize and enjoy the company. They came to keep abreast of what mattered to people in Barrington, and included those topics of importance to Barringtonians on their radio shows.

The shop remained open until noon on Christmas Day, ready for customers who needed to purchase batteries for toys, flash bulbs for "Kodak moments," and to serve as a refuge for people without families who needed a "warm cup of coffee, a bit of conversation, and a taste of home." The part that made the Veaths feel good about the store was the sharing of concern between them and their customers over the years.

"When Nibs had his first heart attack, I know he had more get well cards, many probably purchased at our store, than anyone in the hospital," said Audrey.

In 1984, after almost three decades of non-stop work, and because of Nibs' precarious health, Audrey convinced him to sell the shop, slow down, and travel. "Our kids didn't want to run the shop," Audrey said. "They knew how hard we had to work to make a go of the place."

So, after college, the kids chose different careers. Christie works for Ela Township Library as senior outreach program director. Peggy is a nurse and discharge planner at

"Nibs" Veath and his brother Jim at the door entrance to the "Shoppe." The brothers were dedicated to offering Barrington customers service, smiles, and a pulse on the political climate of the village regarding schools, sports, and "local color." (Photo courtesy of Audrey Veath.)

Audrey grew up in the heart of Barrington's village. The family's modest home did not have running water nor electricity for a long time. Yet, she remembers with fond memories her Station Street childhood days when she played with friends in the street, as cars were few and far between on Barrington roadways. (Photo courtesy of Audrey Veath.)

Good Shepherd Hospital, and Andy is a firefighter-paramedic in Cary. "I'm glad all three children live close by with their families."

When the Veaths closed the doors of the Town Shoppe, they took trips to Ohio, Indiana, Pennsylvania, and Kentucky to attend Mennonite quilt auctions. They were so impressed with the variety and quality of the quilts that they began collecting them. Audrey has over 30 quilts and each and every one of them is a favorite. "I am especially fond of the baby quilts; the colors and designs are so charming. Because of my interest in buying and collecting quilts, I have acquired many dear friends among the gentle Amish-people I have met.

It was also during this period that the Veaths learned about Heifer Project International. They began sending donations to the organization. As they became better acquainted with the program, they began encouraging others to contribute funds as well. Nibs and Audrey were attracted to HPI's goals of providing food, income-producing farm animals, information, and assistance to families around the world.

Heifer Project International is based in Little Rock, Arkansas. It models the humanitarian work begun in 1937, by Dan West of Hoosier, Indiana. After observing the devastation to Spanish land and animals during its civil war, West decided to assist Spanish farmers in reviving their agriculture and husbandry programs. He recruited volunteers to procure animals to replenish farms.

"West realized that what the people needed was not cups of milk, but a cow," noted a HPI volunteer.

Audrey Veath (pictured at age five) remembers Barrington as a "wonderful place" to be raised and as a small town where adults acted as every child's surrogate parents. It was a simpler time when doors were left unlocked, kids were free to play outside after dark, and neighbors knew their neighbors by face and name. The world is a different place today. Sometimes people live right next door to one another and never get acquainted. Children are left more to their own devices and doors are always locked. "I never realized how blessed we were, raised when we were, and raised under the conditions that we were," says Audrey. (Photo courtesy of Audrey Veath.)

During much of World War II , HPI was dormant. Then it began to rebuild in 1944, when 17 heifers were sent to Puerto Rico. The first three cows to arrive were named Faith, Hope, and Charity. After the war, dairy cows were sent to Japan and Europe to replenish their war-depleted livestock. "We were immediately drawn to the unique ecumenical nature of the Heifer Project."

Audrey increased the attention she gave to HPI after Nibs died on Aug. 26, 1994, while undergoing a fourth heart-saving, but experimental, operation. She began raising funds for the program through quilt auctions, school fund-raisers, and gift donations. She organized the 1997 auction and collected quilts, raising $58,000. The second auction in November, 2000, brought in another $58,000.

The animals-can-change-lives philosophy of HPI is not foreign to Audrey, who spent summers visiting and working on her grandparents' farm near Elgin; her parents raised rabbits, guinea hens, chickens, ducks, a goat, and a pig when they lived in the heart of the village.

In addition to keeping animals, "we canned fruits and vegetables, made jams, picked berries, and made our own butter. Dad kept our butchered meats in a storage locker at the Jefferson Ice House. It became a popular facility since neither ice boxes nor freezers were available to people of average means. My mom also cleaned and dressed game birds—pheasants, ducks, and geese—for local hunters. She saved the feathers and shipped them to feather merchants. The income she earned really helped our family."

While raising funds, Audrey hosted a number of Heifer Project International staff in her

When Nibs was in rehabilitation after several heart attacks, he befriended artist Ron Nelson who drew this caricature of Nibs behind the counter at the Town Shoppe. Nelson presented the Veaths with the delicate water-color portrait shortly before his own death due to heart disease. Nelson captured the spirit of the fabled Town Shoppe in his work. (Sketch courtesy of Audrey Veath.)

home. In 1995, she welcomed James Tinkamanyire from Uganda for the Christmas holidays. He was in the United States for a 6-month partner-in-residence program. The Reverend David Boothley of Goshen, the regional director of HPI, brought Tinkamanyire to the Cary-Barrington area to share his family's story with congregations of several churches. He told audiences that after the Ugandan civil war, there was no governmental

Audrey and Wilbur "Nibs" Veath pose for a formal wedding day photo on December 8, 1951. Audrey met her future husband while working after school at the Town Shoppe. The couple married six months after her high school graduation "because he did not want his best employee to get away." (Photo courtesy of Audrey Veath.)

structure in place to help his war-ravaged people. HPI was asked to come in and bring their novel form of aid. The Cleveland HPI group sent him a cow. Over time, it was bred and produced bull calves to sell and heifer calves to raise and pass on to other needy families, providing the Tinkamanyire family with much needed food and funds. James described how the gift of his cow changed his family's life. He was such an eloquent speaker that HPI

collected a great deal of local support and funds after each of his presentations.

"One animal, one cow, turns lives around," said Tinkamanyire.

Audrey's first HPI trip came in 1997. She visited the East African countries of Tanzania, Kenya, and Uganda. Apart from mini-trips to Mexico and Canada, it was her first venture so far away from home.

"I remember being awakened the first morning by the haunting sounds of lyrics coming from a nearby mosque, calling upon the faithful to begin their day with prayers. I was also impressed by the fact that people walked—they walked everywhere—to the center of town, to market, to visit friends, and to accompany their children to school.

Another thing that struck me was how much time East Africans spend outdoors. They use their homes to sleep and sometimes to eat in, but most of the time they're outside visiting with one another. I really had a sense of the importance of community in their lives.

Everywhere our group stopped, we were treated like royalty. People made us tea, boiled milk, or purchased soft drinks, knowing we were unable to drink their water because we weren't use to it," said Audrey. "Hospitality abounded among these friendly people."

On this trip, HPI members saw for themselves how the organization helped change the landscape and the people living in these isolated villages. They saw the dramatic economic and social effects which result from a shipment of cows, sheep, goats, pigs, and chickens

The Veaths' children, shown here in a 1962 Christmas photo are pictured from left to right, Andy, two; Peggy, four; and Christy, eight. As adults, all three children remain in the area with their families. Andy is a firefighter-paramedic in Cary, Peggy is a nurse discharge planner at Good Shepherd Hospital, and Christie works for the Ela Township Library as senior outreach program coordinator. (Photo courtesy of Audrey Veath.)

Audrey Veath's sister-in-law, Marion Johnson, started the Town Shoppe in the mid-1930s with her partners, Harry and Ethel Munsig. Fresh out of business college, the trio opened the coffee shop on Cook Street. The business prospered and they expanded their merchandise. Soon the shop specialized in homemade soups, sandwiches, and pies. The shop remained in the family until December, 1984, when Audrey and Nibs closed its doors for the last time. Today, Marion lives in California. She is a vibrant 86-year-old and tells vivid stories of her years spent helping run Barrington's celebrated Town Shoppe, where locals were able to come on warm summer evenings to cool off with assorted refreshments.

Pictured here, from left to right, are four generations: (front row) Christy, Benjamin, and Grandma Witte; (back row) Audrey. The photo was taken for Benjamin's christening in 1983. He is the first grandchild of Audrey and Nibs. The Town Shoppe celebrated his arrival with a sign that covered the store front window and read, "It's a boy!" The community celebrated with the Veaths. (Photo courtesy of Audrey Veath.)

Peggy graduated from nursing school in 1979. Here, she celebrates the occasion with her mom and dad. Peggy now works at Good Shepherd Hospital in Barrington. (Photo courtesy of Audrey Veath.)

arriving in a community. "These animals prosper and multiply, enabling families to barter, trade, negotiate, put new roofs on their houses, send their children to school, and provide the people with better health care. Seeing all of this, we felt the presence of God."

It was during this trip to East Africa that Audrey was able to visit James Tinkamanyire's village. While in Africa, HPI members witnessed another important facet of the organization's humanitarian philosophy: the Passing on the Gift ceremony when the first born female animals are passed on to other needy families. This ensures continuity of the project, builds solidarity among communities, and increases the benefits of the original gift for future generations.

During their visit, the HPI group attended a dinner at the Baptist Church on Mount Meru, Africa's third largest mountain. There they participated in a ceremony, carving a freshly roasted goat into bite-size pieces and handing pieces to each other. The Baptist minister and the HPI Director were the first to exchange bites of meat. Then everyone else joined in, eating the rest of the goat meat. "It reminded me of a bride and groom sharing a piece of wedding cake. It was very moving, and it was an honor to see this extraordinary ritual," said Audrey.

Just back from Africa, Audrey received a phone call from a friend who asked her to come with her on a United Church of Christ-sponsored trip to Guatemala during Holy Week. At first Audrey hesitated, then decided, "I have my passport and shots, why not go?"

She's thrilled she agreed to go. The 9-day trip was another journey into an unknown

Peggy, on the left, is arm-and-arm with her brother and friend, Andy. The photo, taken in 1980, represents the strong bond that links Audrey and her three children and their families. Raising her family in Barrington was a "joy," said Audrey. "Because all of our children worked in the Town Shoppe after school, we always knew where they were."

land. The poverty of life was shocking. Because the Guatemalan civil war had just ended, villages were in ruin, menfolk were missing or killed, and women went about the business of raising children alone.

"I was thunder-struck by the amount of raw-gut courage displayed by many all through the area. We met a tall, blond doctor from Madison who works in a hospital emergency room in Wisconsin for six months a year, saves his money, and comes here to run a clinic for the Indians. When money runs out, he returns to Madison and begins the cycle again."

The United Church of Christ group visited a new community near the Mexican border. Here, they saw women weaving brilliantly colored textiles, proud to show off their school whose library consisted of one shelf and a few books. "Nevertheless, we saw hope in their eyes, smiles on their faces, a deep sense of spirituality," Audrey said.

The most spectacular sight was the Holy Week Procession. Beginning on Good Friday, men paraded down the main street carrying heavy platform-floats with statues of Mary and the crucified Christ on their shoulders. They took 30 steps forward and 29 steps back along a path lined with brightly colored sand and flowers. Once the paraders passed, children gathered the sand and kept it for "good luck." Early Saturday morning, the pilgrimage ended in an enclosed courtyard. In the flower-strewn, incense perfumed garden, one villager had the honor of dancing with the statue of the Virgin. Round and round he went in trance-like fashion until the sorrow on the Virgin's face disappeared and a "smile" appeared.

"I was deeply affected by the total spirituality of the ritual. It is something I won't soon

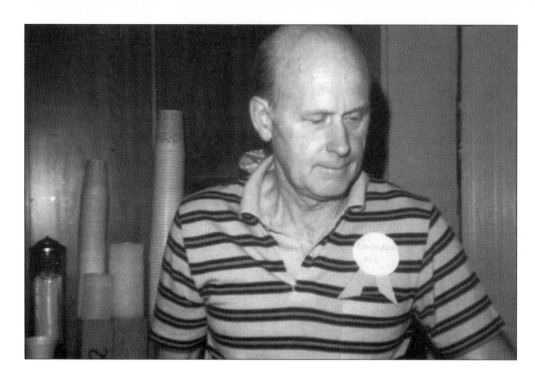

Nibs awaits customers behind the counter at the Town Shoppe. The hours were long, the work was non-stop, but the espirit de corps *generated in the store made it all worthwhile. What other job can you have that allows you to enjoy time with family and friends every day? Below, Nibs relaxes on a warm summer's evening as his grandson, Benjamin, shows grandpa how he uses his toolbox.*

Audrey Veath is on a mission: to help people in the remotest corners of the world become self-sufficient. She works doggedly to raise funds for Heifer Project International in order to supply families or villages with a goat, cow, rabbits, or hens so they can learn how to take care of the animals, raise them, and share their offspring with others. (Photos on this and the next page courtesy of Audrey Veath.)

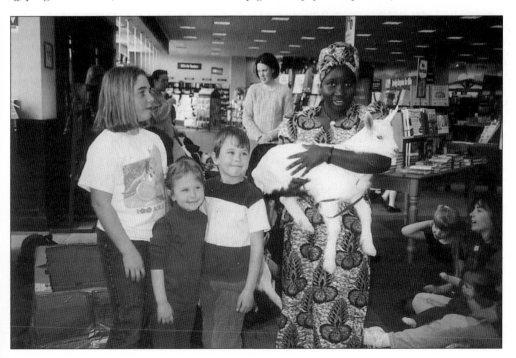

Top: *Audrey Veath understands the part animals can play in the well-being of families, especially in poverty-stricken areas of the world. On the left is the logo of Heifer Project International.*

Bottom: *Audrey introduces Beatrice, visiting from Uganda, to a group gathered at a local library. Beatrice's family was given a goat by Heifer International several years ago. The experience so changed her life that Beatrice, with the help of Page McBrier, has written a book called "Beatrice's Goat." The young woman came to America to share her story and enlist others in aiding families through Heifer International.*

Audrey continues to campaign for funds to assist those less fortunate in North America, Latin America, the Caribbean, Africa, Central and Eastern Europe, and Asia and the South Pacific. She has raised hundreds of thousands of dollars through Amish quilt sales and other means. She is a woman with a goal and her efforts are working wonderfully.

forget," said Audrey.

In June of 2000, she traveled to China and saw further evidence of the positive, practical results of HPI's people-to-people program. "We met a young man who has become a rabbit-millionaire. HPI sent him several pairs of rabbits that ultimately have reproduced thousands. He has given hundreds to people in need. Meanwhile, his breeding efforts continue and so do his gifts of rabbits to others. That's what this program is about: helping people become financially independent, and encouraging them to help others in return." Audrey admits that on that last trip she fell in love with China: the people, the food, and the breathtaking scenery. She plans to return as soon as possible.

"There is so much satisfaction when you leave the beaten path and journey beyond the capital cities into the hinter-lands and see the sweeping changes brought about for a family and for a community by merely supplying them with cows, goats, or chickens," she said. "HPI has renewed my life. It has given me an opportunity to travel, to meet people, to have a new focus, to have a new passion."

Today, in her understated manner, Audrey Veath is sharing the same sense of community with people in other, distant villages that she and Nibs nurtured during their days as owners of Barrington's Town Shoppe.

VIII.

Gene Wolfe

Gene Wolfe's salt-and-pepper, handlebar mustache frames his broad smile. His piercing hazel eyes look out through silver-rimmed glasses, surveying his surroundings. This tall, robust man has traveled many highways from his childhood in Houston, Texas, to his red-brick ranch in the heart of Barrington.

Gene leans on a walking stick elaborately carved with an Italian village scene. "My friend, Joe Mayhew, a librarian for the Library of Congress, made this for me. When he came to visit us, we'd sit in my office or in the backyard, and we talked endlessly while Joe whittled. For years we phoned each other once a week; our conversations never dragged. He died recently and Rosemary and I miss him terribly."

Gene Wolfe is a natural storyteller. He was raised by parents who lavished their love of books, words, and stories on him. Born May 7, 1931, ten years after his parents married, Gene was their only child. They met on one of his father's business trips to the south. His mother grew up in Belhaven, North Carolina, and a remnant of her southern drawl can now be heard in Gene's speech.

His mother, Mary Olivia Ayers Wolfe, easily sported a boyish figure much admired by flappers of the twenties. A gastric ulcer prevented her from eating more than a few bites of food without pain. "Her father made her take the medicine that he used to worm his dogs," said Gene. "He was a cruel man who beat his wife and children regularly, but he spared my mother for some reason. Once, when my mother and I went by train to visit him, he never spoke to me and threatened me with his cane when I came too close to him. Men like that leave lasting impressions on a small boy."

Gene's father, Roy, worked in the oil fields in Texas. Then the family moved to New York where Roy's father took a job as an office secretary. During the Depression, he sold— or tried to sell—cash registers. When the New York job ended, Gene's parents moved to Peoria, Illinois. Gene's first love, Rosemary Dietsch, who became his childhood playmate and destined to become his wife, lived next door. "One hot day, my mother discovered us five-year-olds strolling down the sidewalk 'buck naked'."

Gene Wolfe is a masterful storyteller. He blends his technical training with his love of writing and has legions of fans who applaud his ability to weave together these seemingly different worlds.

From Peoria, the Wolfes moved to Logan, Ohio, Roy's hometown. "Grandmother's house had been a station on the Underground Railroad and had a secret room in which runaway slaves were hidden until they could obtain safe passage north." But it was another feature of Grandmother Edith's house that had the most effect on Gene. She had saved many years of Sunday funnies for his cousin Jack and him. Stacks of *Flash Gordon* and *Buck Rogers* offered his first exposure to science fiction and fantasy. These magazines and newspaper clippings nurtured his life-long attraction to futuristic tales.

The Wolfes moved again—this time to Des Moines, then to Dallas, and finally to Houston, which he thinks of as his "hometown." His parents enrolled him in the Edgar Allen Poe School, where children as young as seven were required to read Poe's works, including "The Murders in the Rue Morgue." Gene's memories of school also include "air raid drills, tarantulas as big as a man's hand, and cockroaches as long as a Waterman fountain pen. Hurricanes brought us rattlers from the salt marshes." His story, "Houston, 1943," is based on his Texas boyhood.

After the bombing of Pearl Harbor, many of Gene's cousins and uncles who were in the service were shipped overseas. "We were afraid that my father would be drafted too, but he never was." The hot summer nights in Texas were spent at Galveston Beach sitting on a blanket, watching the orange glow of torpedoed tankers on the horizon. The Gulf swarmed with German submarines.

When he entered junior high school, Gene's dad bought him a used bicycle so he could bike to school, but, "halfway through the first year, I skidded on gravel and took a good

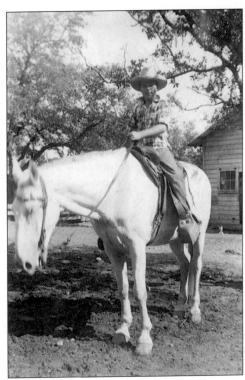

Gene's love of nature and the out-of-doors was developed early in his youth. Like most kids his age, he dreamed of being like his cowboy heroes—Tom Mix, Hop-a-Long Cassidy, and Roy Rogers. Then he discovered stacks of comic book his grandmother had saved for him, and his heroes turned to super heroes; he's never looked back. (Photos on this and the next page courtesy of Gene and Rosemary Wolfe.)

deal of skin off my left leg. My leg still bothers me sometimes." Since he could no longer ride his bike, his mother had to drive him to and from school. She was a fan of stories by Ellery Queen, Agatha Christie, and Rex Stout. She had read to him from an early age. His dad preferred the works of H.G. Wells and Jules Verne. Both his parents shared their passion for books with Gene, but he stubbornly refused to read their books. That changed one day, when he picked up a book his mother was reading: *The Pocket Book of Science Fiction.* The first story he read was "Microcosmic God" by Theodore Sturgeon and rekindled his childhood ardor for futuristic stories.

Gene began consuming volumes of *Amazing, Astounding, Planet, Thrilling Wonder,* and *Startling Stories,* magazines with stories set on distant planets. Gene couldn't get enough science fiction. When he graduated to high school and felt isolated and lonely. He met two other boys who also had an interest in science fiction and the three teenagers set up a loan-and-share science fiction and fantasy exchange. They talked about the stories they read and were absorbed by worlds far removed from their high school.

Gene joined the ROTC and before graduation, he joined the Texas National Guard, which gave him a new set of friends along with his first plane ride. But the greatest impact on Gene's high school days came in Miss Collins' English class. His writing skills were developing, and she encouraged him to use his talent. For a young man who disliked

sports, writing became a natural outlet.

His parents' wishes for him to attend college were fulfilled. During his second year at Texas A&M, Gene typed papers on the typewriter his parents had given him when he graduated from high school. His roommate, Lou Hampton, urged him to write for the school literary magazine, *The Commentator*, and Gene accepted the challenge.

"Texas A&M—then all male—was cheap, yet well regarded; it was brutal as only a bad military school can be. I studied mechanical engineering, did my only hard drinking, and dropped out in the middle of my junior year."

Inducted into the Army on August 13, 1952, he was sent to Ft. Leonard Wood, Missouri, for basic training. He was drilled on map-reading and chemical and biological warfare before being shipped to the Far East aboard the *U.S.S. Patrick* headed for Korea. "I almost died en route. I was Corporal of the Guard, and while inspecting my sentries around midnight, I nearly went overboard in a raging storm. By then, I was 6-feet tall, and the railing caught my hip. The sensation as my center of gravity shifted from one side of the railing to the other and my feet leaving the deck, is one I can still feel."

Gene's military division fought in the Battle of Pork Chop Hill, a battle infamous for the number of French and American casualties. "The war I entered was one of trenches and bunkers, barbed wire, machine guns, land mines, sandbag walls, and artillery bombardments." The closest Gene came to injury was when shrapnel hit the thigh of the soldier who was lying on the ground next to him. "In Korea, I learned what a friend is: someone who will let you drink from his canteen and keeps watch while you sleep." After the cease-fire, Gene spent the next ten months traveling in the Far East before his

Gene Wolfe and his mother-in-law, Mrs. Dietsch, had a unique relationship, as Gene had grown up next to the Dietsch family and played with his future bride when they were both small children. Rosemary kept in touch with Gene's mother when Gene's family moved to Texas. When Rosemary traveled to Texas for a visit with Gene's family, a romance developed. The couple were soon engaged, and then married on November 3, 1956. Former neighbors were now related in the most wonderful way.

After service in Korea, Gene Wolfe graduated from Texas A&M. At the time he attended the school, it was inexpensive and all male. While at A&M, Gene wrote for "The Commentator," the school literary magazine and also joined the ROTC. He was inducted into the Army on August 13, 1952, and was sent to Ft. Leonard Wood, Missouri. Wedding photo of Rosemary Dietsch and Gene R. Wolfe, November 3, 1956. (Photo courtesy of Gene and Rosemary Wolfe.)

discharge and return to Texas. His parents wanted him to go back to college, but Gene had no intention of resuming his studies at A&M. He lived at home and went to the University of Houston instead.

Home from the war, he renewed his friendship with Rosemary Dietsch who had kept in touch with Gene's mother and had come to Texas for a visit. Rosemary and Gene married on November 3, 1956. "We had no money," Gene recalls. "The only furnished apartment I had been able to find was a two-room finished attic; one room was our kitchen, and the other was everything else." Then Gene came across an article stating that Gold Medal Books guaranteed a $2,000 advance for original paperback novels. He resolved to write one, did so, and sent the manuscript to Gold Medal Books. It was rejected, but he continued to write whenever he could for the next eight years, though nothing sold.

Four children were born to Gene and Rosemary: Roy II , Madeleine, Therese, and Matthew. With his degree in mechanical engineering, Gene began working in Ohio for Procter & Gamble's Research and Development Division, a job he held from 1956 until 1972. It was during this period that he helped engineer the machine that cooks Pringle Potato Chips.

Drawn to an article on crocodiles in *Reader's Digest*, Gene was reminded of Kipling's "Undertakers" story. He combined elements of both and wrote a ghost story, "The Dead Man," set in India. He sent it off to several publishers, from the prestigious *Atlantic Monthly* to the skin magazine, *Sir!*. On June 4, 1965, he got a letter from *Sir!* telling him that his story would appear in the October issue. A check for $80 followed. "At last, I was a writer," says Gene. It was three months before he made his next sale, but then others followed.

Gene sent the stories he wrote to science fiction markets listed in alphabetical order in

The Writer. He sent "Mountains Are Mice" to *If* magazine. When it came back, he addressed another envelope and sent the same manuscript to *Galaxy*. He was unaware that Frederik Pol was the editor for both magazines. Pol wrote back, "Although I don't think the story is right for *Galaxy*, I can use it in one of our other magazines." A check for $65 arrived after Pol renamed the piece "Mountains Like Mice." Ironically, Pol now lives in Palatine, and his wife teaches at Harper College.

Gene had found his niche and joined the Science Fiction Writers of America. Damson Knight was the group's founder, and the editor of *Orbit*. Gene sent Knight an experimental story featuring letters supposedly written and exchanged by a medieval knight and an astronaut. Knight liked the trans-century story concept and sent the manuscript back to Gene for editing. It appeared in *Orbit 2*. From then on, he sent all his stories to Knight first. "He had the greatest influence on my career."

The second greatest influence on Gene's writing was the Milford Writers Conference, held in a Victorian mansion in Milford, Pennsylvania. "Being in the presence of talented writers and being treated as an equal by them was an experience comparable to seeing Manhattan and the Grand Canyon together. These were men with whom I could walk and talk." It was a supercharged atmosphere of week-long manuscript discussions, writing assignments, and editing sessions. It was here that he matured as a writer. "Egos were stroked or bruised, stories were praised or destroyed, skills were improved and polished, and participants left as better writers for having attended the conference."

As a result of participating in the Milford Conference, Gene wrote *The Fifth Head of Cerberus*, which eventually became a 100,000 word novel. He sent it to Knight who agreed to publish it. But Gene wasn't satisfied with the story. He took *Cerberus* to the next Milford Conference. In attendance at the Saturday night party that ended the conference was Norbert Slepyan, who headed the newly established Charles Scribners and Son Science Fiction Division. Slepyan liked Gene's book and wanted to publish it if Gene were willing to write a sequel.

The Fifth Head of Cerberus received favorable reviews. Douglas Barbour wrote in *Contemporary Literary Criticism*, "Wolfe uses *Cerberus* to raise the deepest question about human identity. There is a dark heart of mystery to this tale which is chilling ... Wolfe has created a truly gripping . . . story."

The publication of *Cerberus* was a turning point. Living in Ohio, at home with four small children to raise, Rosemary became homesick for Illinois. Gene remembers nights when she would "cry herself to sleep." He looked for a new job, resigned from Procter & Gamble, and moved to Barrington. He became a senior editor at Technical Publishing and was relieved that he didn't have to deal with an hour-long commute to work. His editing job paid more than his engineer job, and because Barrington was close to Chicago, the move enriched the Wolfe family's life in many ways. They were able to enjoy a circle of literary friends, take the children into the city to explore its grand museums and galleries, and to attend plays.

In 1984, Gene quit his editorial post at Technical Publishing so he could write full time. Considered one of the literary giants of science fiction, he has published over 240 pieces of writing including essays, books, short stories, poems, and speeches. His work has

Opposite: *Over the years, Gene's novels have received critical acclaim in the world of science fiction. He has been praised for creating an epic stage and one of the richest and most complex characterizations in this field. His faithful readers have made Gene's epic journey with him from book to book.*

GENE WOLFE
THE CITADEL OF
THE AUTARCH

THE
SWORD OF THE
LICTOR
Volume Three of *The Book of the New Sun*
BY GENE WOLFE

GENE WOLFE
LAKE OF
THE LONG SUN

The second
volume of
*The Book of
the Long Sun.*

CASTLEVIEW

A NOVEL BY
GENE WOLFE

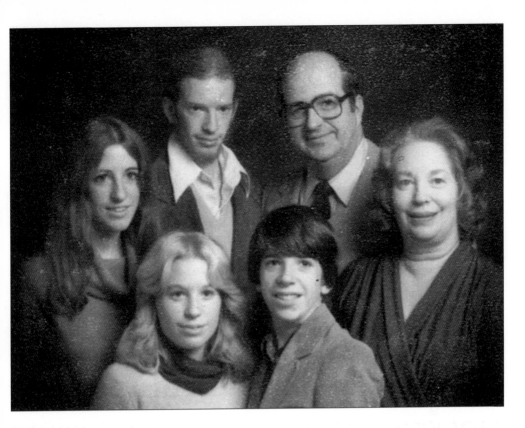

This Wolfe family photo includes Gene and Rosemary, Roy and Madeleine, and Therese and Matthew.

garnered many awards. Among the most important are three World Fantasy Awards and the Nebula Award for best Science Fiction novel. His works have been translated into French, German, Spanish, Dutch, Danish, as well as other languages. He has appeared on stage with Isaac Asimov and is a frequent presenter at science fiction conventions and workshops.

His distinguished career has enabled him to blend his mechanical engineering background with his love of words. Through his science fiction, he is able to imagine what future technology might offer. In the *Book of the New Sun* series, he explores the future on Urth, a dying planet where the sun is red, stars are visible during the day, and all the wealth is horded by a few powerful tyrants. He uses his technical background to create books that readers are drawn to and that give them an opportunity to escape their own realities. "The books and stories I write do not teach readers how to build a barbecue or to get a better job. Rather, my work is intended to make their lives more tolerable, to give them the feeling that change is possible, to let them know that the world need not always be as it is right now."

Opposite: *Gene Wolfe was awarded the Grand Masters for Life Achievement in 1996. His science fiction-fantasy fans like to curl up with his works and travel to the futuristic-fantastic worlds, which Gene has fashioned for them in precise detail. His series of "Sun" novels has been dubbed "a landmark of literature."*

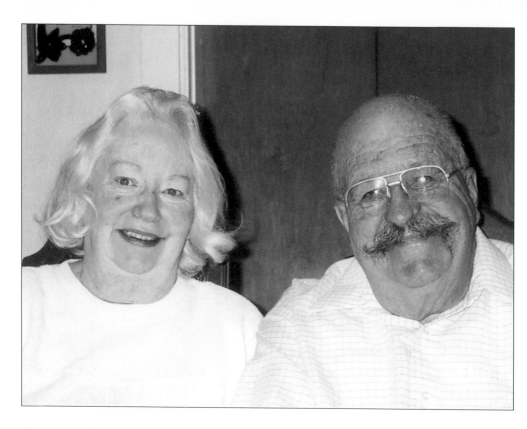

Rosemary Wolfe is Gene's most loyal fan. The couple married in Texas in 1956, but they have known each other since they were two. They raised four children in Barrington: Roy, Madeleine, Therese, and Matthew. "Could a former engineer who helped invent Pringles be our greatest living writer?" asks Nick Gevers of the Washington Post.

Gene Wolfe's writing is more than escapist fiction. His writing is provocative and profound. Joan Gordon says, "Wolfe's fictions are complex, they are meticulously crafted. They are characterized by lonely or disturbed children, have settings of great antiquity or futurity, revolve around alien or invented myths, and shoulder his recurring themes of isolation, memory, faith, and the search for self and human identity." His legions of fans claim he is a writer for the thinking reader. In the *Washington Post*, John Clute wrote, "Gene's *Book of the New Sun* series is "time travel, space travel, teleportation; laser duels and gentle Mammoths; delirium and dreams . . . a Eucharist, layer after layer . . .""

Leaning forward in his chair, Gene rests his tall frame and broad arms on his walking stick. "My life is full. I have a lovely wife, wonderful children, charming granddaughters, and a cadre of friends and fans all over the world. Through my writing, I am able to examine the meaning of life in unique settings and different times. How more fortunate can any man be?" Retire? Not Gene. He is up at five, makes a cup of green tea, lets out his dogs, Dilly and Lammy, skims the newspaper for ideas, and is at his desk by 6 a.m. doing what he loves best: writing.

T.R. Youngstrom

On May 25, 1999, Lee Youngstrom accepted Barrington High School's Distinguished Graduate Award for her son, T.R. Youngstrom, who died in a helicopter crash in Chile while doing what he loved best in the pursuit of his profession. In her presentation to the audience of loafer-clad, blue-blazer dressed students and their parents, Lee said that her son had never owned a pair of loafers, nor a blue-blazer. But he did own over 20 pairs of skis, numerous pairs of hiking boots, and assorted pairs of climbing shoes. At the awards assembly, Lee challenged BHS students to be courageous, to feel free to break out of the expected mold, to challenge themselves to stand up for their ideals, even if they had to stand alone. Lee assured the students that these were the qualities that made her son a legend in his home of Telluride, Colorado, in world sporting events, and in photography.

Lee Youngstrom is a striking woman with golden blonde hair, Colorado-blue eyes, and an enduring smile. Lee's love of T.R. spills forth as she talks about him. The walls of her antique-accessorized home are covered with photos of both T.R. and photos taken by him. His fresh-from-the-beach handsome, willowy, and commanding presence is everywhere.

Thomas Robert Youngstrom was born in Greenwich, Connecticut, on December 8, 1965. He was nicknamed T.R. before he was born. He was teased by friends that the letters stood for Totally Radical or Totally Rich, but his avoidance of collecting material goods made the latter nickname ludicrous.

After moving several times, T.R.'s family settled into Barrington's Westwood community when he was nine. The family-focused neighborhood embraced the Youngstroms, and T.R. quickly became a neighborhood idol. Whatever he did—skiboarding or biking— other kids in the neighborhood followed his lead.

From an early age, T.R. developed a philosophy of living on the edge. He continually tested himself physically and mentally. He created his own physical training equipment by building a climbing wall in the family garage and fashioning ski hills in the front yard. Lee said, "Every night after school he would rush home, pack the freshly fallen snow, and carry out buckets and buckets of water to produce mini-moguls." T.R. took his first ski lesson when he was five.

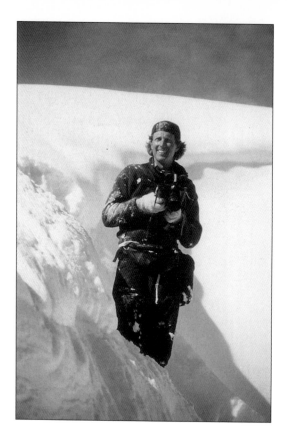

"It didn't go well." After several spills and tumbles, he said to his mother, "Skiing's not for me." But minutes later, there he was standing upright on another pair of rented skis, ready to tackle the new sport once more. T.R. shared his love of skiing with kids in his neighborhood, teaching them how to fly down his homemade mountains of snow and ice.

While growing up in Barrington and continually urging each other on, T.R. and his friend, Matt Rodosky, scaled nearby railroad bridges, body-surfed off the Norge ski jump in Fox River Grove, and skied down the backside of a nearby hill after it had been roped off. According to Matt, "We climbed every building in Barrington and got chased off most of them by the police. T.R.'s motto was 'If you're not scared, you're not having fun.'

"When T.R. was in seventh grade," said Lee, "he took control of another aspect of his life: school. One evening I went to his bedroom and T.R. was sitting at his desk doing homework." I asked him, "When are you going to finish that research paper that's due?"

T.R. turned in his chair and said, "Mom, see that door? You don't ever need to ask again about my assignments until I graduate." Lee didn't. She knew that her son was a remarkably resourceful young man who could make good decisions about his own life. He understood what he needed to do and had an innate ability to do the job. "He might take the non-traditional path," Lee says, "but he always arrived at where he had to be."

T.R.'s career as a photographer began and was nurtured at Barrington High School. Under the tutelage of both the art teacher, Dave Engel, and the photography teacher, Jeff Dionesotes, T.R. learned to see the world in a different way. In Dave Engel's art class, he discovered he could express himself with his hands and once he recognized that

T.R. was renowned for his snow-in-your-face photos in which he captured skiers and their challenges. He combined his love of sports and photography in all that he did. That is why his photos grace the pages of so many magazines.

T.R. preferred to shoot in backcountry snow areas where he could capture man against nature and nature against man as skiers "pushed the edge" at every turn and downhill slope. When the snow was fresh and deep and the skiers tried to defy gravity, T.R. was there to seize the events. His photos are a testimony to the ski scene and skiers all over the world; from Italy to France, Japan to Chile, Mexico to Central America, his camera captured it all. T.R. understood skiers: He was "one of the best of them."

T.R. Youngstrom had a reverence for life. It showed from his earliest days when he turned the family's snow-covered lawn into a mini-mogul field. Life energized this physically-chiseled, charming young man. T.R. was gifted with great athletic prowess and an eye that viewed the world from a fresh perspective.

knowledge, he carried it with him ever after.

Lee says, "I remember when T.R. came home from school one day and described how blown away he felt as he watched an image that he had shot with his camera emerge on paper in a bath of liquid chemicals. That experience taught him that a camera lens would allow him to capture a picture that his eyes identified and then keep it permanently."

The summer he was 16 years old, T.R. begged his parents to let him spend part of it on an Outward Bound course in Colorado. After some reluctance, his parents agreed. With a camera in tow, T.R. started taking pictures of the outdoors; his passion for photographing unspoiled landscapes was born and grew with him.

After graduation, T.R.'s parents wanted him to choose a college close to home. They drove him to Ripon College in nearby Wisconsin, but when they arrived, T.R. looked around the campus and said, "Mom, this isn't the place for me. I want to see the world and I can't see it from Ripon." His parents hadn't known that T.R.'s sights were already fixed on the University of Colorado at Boulder.

Like many students who wander off to Colorado's mountain regions for college, T.R. never came back to the flat plains of Illinois—except for brief visits. He found a mistress, one bejeweled with snow-packed peaks, deep valleys, virgin trails, and purple-pink sunsets: the Colorado Rockies.

T.R. was so seduced by Colorado fresh-powder skiing that he asked his parents to join him in Boulder for a family conference. Fearing where the meeting might lead, his parents flew to Boulder to meet with him. At a café near UC-Boulder, T.R. explained to Lee and Tom

In Bike *magazine his friend, Rob Story, says of T.R. "He was a great guy to shoot with—organized, quick, and seemingly happy not noticing the effort it takes to carry a heavy photo-pack up steep hills at high altitudes. He thrived on finding new and creative ways to shoot . . . life."*

T.R. possessed a highly developed sense of fun. His enigmatic manner captured people everywhere he went. He made forming life-long friendships a way of life. One of T.R.'s favorite books was Oh, the Places You'll Go *by Dr. Seuss. Is it any wonder for a young man who dreamed the dream?*

that during the winter term, he wanted to quit school to ski competitively and teach skiing. He promised that in the summer, when the lure of snow-covered mountains abated, he would take a full load of classes. Lee worried that the mountainous snow-siren would overpower her son, and he wouldn't finish college. But T.R. had set his goals, and Lee and Tom prayed he would follow through. T.R. graduated from UC-Boulder in 1988, with a B.A. in photography and a minor in Spanish, a language he used often, and successfully, on his global journeys.

T.R.'s professional career as a photographer began right there in Boulder when he started shooting pictures of local climbers. A friend of his had said, "These are great—why don't you submit them to a magazine?"

"Are you kidding?" T.R. asked.

Finally, he sent off some shots. *Climbing Magazine* published one and sent T.R. a check for $150. "I was amazed. I could live on this for months! I couldn't believe someone actually gave me money for one of my pictures," he had said.

He did freelance photography for a year in Winter Park, then for a year in Aspen, and finally settled outside Telluride. During the next several years, T.R.'s photography

T.R. Youngstrom's mom, Lee, shares this letter which was from T.R.'s friend, Bob, which was typical of the letters, cards, and messages she received when T.R. died while on assignment in the snow-covered mountains of Chile.

December 1, 1998

Dear Lee,

I hope this note finds you doing well. It's long overdue and something I've been meaning to get to since last year. What put me back on track to write to you is something that happened recently while I was in my local flyshop.

My friend Paul, who owns the shop and is generally a nice guy, had just hung a photo on the wall. It was an ad for one of the brands of flyrods called "Scott." He commented on what an awesome picture it was – we both did. It's a photo of two guys walking across a field with their flyrods. Perfectly composed, the two men are dwarfed by towering mountains behind them. As I looked closer I noticed, in small type along the lower right edge, the name of the photographer. It read: T.R. Youngstrom. It made sense. Scott is located in Telluride—the same place T.R. came to know and call home. As I looked some more at the photo and name along side it, I paused a bit as I remembered my childhood friend. T.R. and I connected on some level, and I've thought of him often over the years. Keeping track of him in a small way by looking for his photo in skiing magazines.

I haven't been skiing for years, but seeing T.R.'s images in magazines always gave me a bit of a kick—he loved to ski and being able to make his living from something he really enjoyed was a great thing to see. It is certainly a long way from skiing down the hill in your front yard during those snowy Chicago winters. I can still see T.R.'s face as he headed down the short slope to the street. Part pleasure, part mischief. But a smile as pure as could be. He loved the snow. He was a great kid to be a kid with. As I turned away from that photo in the flyshop, my friend Paul asked what I had been thinking about. I told him the story of a great man who had been taken away too soon.

Take care,
Bob

assignments took him to the far corners of the earth: Greece, France, Switzerland, Italy, Chile, Belize, Japan, and Nova Scotia, but Colorado never lost its lure for him. His outdoor adventure and mountain guide friend Brian O'Neill says, ". . . [T.R.'s] favorite place, the place he called home for over ten years, was Trout Lake, Colorado, in the San Juan Mountains. T.R. and I spent many a day in the little cabin we shared there, reveling in the beautiful mountain setting that rivaled any backcountry playground we ever experienced in our travels. No matter where he was returning from, T.R. was always excited to get to his

T.R. lived life to its fullest. As a youngster, he and his friends climbed local watertowers, skied down the center of the street in his neighborhood, and generally tested himself at all times. Taking his first class in photography at Barrington transformed T.R. Later on, after living in his car for several months while he looked for assignments, he sold his first picture for $150. T.R. said, "I could live on this for months!" On the left is a photo of T.R. when he was in middle school, and on the right is a photo when he was about two. (Photos courtesy of Lee Youngstrom.)

backyard in the San Juans."

T.R.'s mastery of skiing, snowboarding, mountain biking, and paragliding enabled him to photograph these kinds of athletes with an expert eye. Mike Shimkonis, who works as the communications director for the Telluride Ski and Golf Corporation, said of T.R., "I was very fortunate to have the ski industry's hottest photographers right here in Telluride at my fingertips . . . the living [that] T.R. and two fellow travelers made involved a lot more than shooting the San Juans. Open any climbing, skiing, mountain biking, or other outdoor magazine, and chances are, you'll find their names.

As with lawyers, the threesome—Ace, Doug, and T.R.—kept track of each other's successes and talked shop whenever their cameras were rewinding. And there were never hard feelings when one of them got the shoot—be it in a catalog or for the cover of a magazine."

Of his colleagues, Ace Kvale and Doug Berry, T.R. said, "There's a close camaraderie among us . . . and it's neat because we all shoot a lot of the same things, but our photos don't look alike."

Earning a living as a freelancer is well-nigh impossible and living between assignments can be daunting. T R., who was always one to laugh, said, "During 1990 and 1991, I became severely homeless. I spent the better part of that winter living in a minivan. That's the

ultimate freedom. What fun!"

Despite his struggles, T.R. remained optimistic that year. In a letter to Lee, he wrote, "Am working hard at getting a photography position. I feel confident that I can get it and have sold three photos in the last two months. Sounds unimpressive I know, but it's almost impossible to make a living at this freelancing business in the first five years. I'm actually doing pretty well considering where I am. Ten photos published in the first full year! This isn't bad. . ."

Over time, T.R.'s photos of mountain sports and mountain scenery eventually became a mainstay in many national magazines. He listed among his clients *Snow Country*, *ELLE*, *Bike*, *Powder*, *GQ*, *Skiing*, *Climbing*, and *Snowboard Life*. He also shot for several Telluride-based magazines. After a stop-start beginning, T.R.'s career revved into overdrive.

His innovative eye helped him embrace life with an infectious attitude. "The images he produced stirred emotions and inspired people to pursue their own passions," says a friend in *Snowboard*.

Rob Story says T.R.'s hands set him apart from other photographers. Writing in a September 1997 issue of *Powder*, Story wrote, "Eventually, you notice his hands; he had the funniest hands, connected to gangly arms that appeared to be huge reaching poles especially when his long legs were skinning up a ridge. The thing about his hands is that they just didn't seem to fit T.R. His hands looked old, his countenance young. His face grew only a sheen of peach fuzz on a 5-day backcountry trip. But T.R.'s hands were old, veiny, perpetually sunburned, prematurely wrinkled. . . Did he shoot barehanded in the

The things T.R. did during his short life were things most people dream of doing over a lifetime. This robust young man was inspired at BHS to see the world on the other side of the camera "in a different way." He majored in environmental design and photography at the University of Colorado-Boulder, which launched his career and "fixed" his life. During college, T.R. was a ski instructor and a ranked telemarketer. He later made Telluride his Colorado home. He fell in love with the place where he could hike, camp, backpack, and ski whenever he wished. T.R.'s "backyard" faced Trout Lake and his beloved Rockies.

Ian Kirkwood, T.R.'s friend, wrote a poem for T.R.'s memorial which Kirkwood read at the Sheridan Opera House. In part, it said the following:

> *Love doesn't die,*
> *People do.*
> *So, when all that's left of me*
> *Is love,*
> *Give me away.*

cold too often? No, T.R. said that his hands were a heredity gift."

But with these hands, T.R. turned an ordinary shot into an extraordinary image. He especially loved capturing snow-powdered face shots. He watched skiers ride to the top of a freshly covered slope. Then, as they flew down the side of the mountain with powder spraying around their heads and into their faces, T.R. snapped photos, catching their faces in a whirl of glittering snow-crystals. He traveled the world in pursuit of face shots. He wanted to develop the tools of his trade in order to take better, different, fresher shots. He was in a hurry to record everything he saw.

T.R. did not become a commercial photographer by the usual definition. He accepted clients' checks and cash so he could buy a new-used camera or treat friends to a meal and a beer. The payments enabled him to invite dozens of friends over to his place for an impromptu slide show. He delighted in sharing with his friends all the great images he and his lens had captured. His slide shows were a staple of his social life in Telluride.

When T.R. traveled, he kept in touch with his mother. Sometimes he would phone her in the middle of the night because he forgot about the time differences between wherever he was in the world and where she was in Barrington. He sent letters and postcards sharing with Lee every detail of his adventures—often teasing her to join him on his next shoot.

On assignment in Greece and traveling with another photographer, he took their portraits while they rested on the frames of their bikes at the base of an alabaster-stone village. He sent the photo to Lee and wrote, *Yo, Mom, please send $10,000. Thanks. Here's a photo from the Greek Island of Ios. Love, T.R.* He also wrote, *Hi, Mom. Greetings from the French Alps. Spending every day skiing the best terrain of my life. Loved Paris, Grenoble, etc. Off to Chamonix soon. Doing the "Haute Route" May 6-13 Chamonix to Zermatt. You must come to Paris, you would love it.* One of Lee's favorite T.R. photos features his ski tips peering over a spectacular drop. This photo appeared in a national ski magazine.

From Newfoundland, he penned, *Hi Mom, you would love this place. People are very friendly. B&B's everywhere. Small fishing villages, Victorians. It's very easy to travel here. The old homes are unbelievable. This place, St. John's, is the first settlement in North America. It's very cool. If you come in June, you'll see icebergs, whales, and more. Love, T.R.* He had a deep and abiding relationship with Lee.

T.R.'s last trip took him to Chile in August of 1997. It was a highly anticipated expedition and included two photographers, several skiers, and movie personnel on assignment to film a documentary called "Pura Vida." It was to highlight the undiscovered skiing possibilities in the highlands of Valle Mardones near Portillo, near the border of Argentina. For T.R. there was nothing better than fresh heli-skiing, and this project gave him the opportunity to combine his passion for fresh powder skiing with photography.

For Keith Carlson, photographer for *Powder* magazine, the trip was a trip of many firsts—first major assignment, first time out of North America, and first time in a helicopter. T.R. had already been in Chile for three weeks shooting for Hotel Portillo and Portillo Resort and had other assignments scheduled.

Keith arrived in Portillo in August. The snow was solid and deep, but spring-like temperatures threatened the shoot. The *Powder* crew was exhausted from their hours-long flight and 3-hour bus ride. When the crew met T.R., he greeted them with his broad smile and contagious high energy. After breakfast the next morning, everyone scurried around finishing last minute details before the chopper took them to the location of the shoot.

Carlson recounted what happened next: At 8:45 a.m., the first team left Portillo en route to

In these photos, T.R. caught his beloved mountains fringed with blue-purple lupine and the moon hanging over a snow-laden ridge. T.R.'s favorite place, the place he called home for over ten years, was Trout Lake, Colorado, in the heart of the San Juan Mountains. His photos recorded his passions: the love of mountains, bike trails, and free-falls from the sky. (Photos courtesy of Lee Youngstrom.)

Top: *T.R.'s prize-winning photos had an alluring seductiveness to them. They seemed to say to the natural environment, "We can conquer whatever you put before us: glaciers, snow-packed peaks, edges of the slopes, fields of ice." He often shot where it was cold and isolated, but he was always happy and never felt loneliness. T.R. thrived on high drama. He was always ready to cheer on a new day, a new assignment, a new demand. A* Freeze *magazine editor wrote of T.R., "He had an obnoxious amount of positive energy and it always rubbed off on everyone around him, so they would end up operating on the same level as he did."*

the Mardones Valley, six miles from Portillo. Two trips were necessary to get the entire team into position. Frank Coffey, the snow safety director at Portillo, should have been the first man on board. He usually goes up in the first helicopter, but since he had never landed in this particular zone before, the experienced Juan Pinto Fernandos, retired Chilean Air Force pilot from Santiago, went on the first trip and Frank waited for the second trip.

The turn-around time for the trip should have taken no more than 20 to 30 minutes. So after 30 minutes of waiting for the helicopter, Frank telephoned the base station and asked the operator to contact Pinto. The base reported that the Mardones was out of radio contact. After 45 minutes of waiting, Frank requested a helicopter to do a fly-over to check out the situation and to try to establish radio communication with the first team. The fly-over was accomplished.

Frank flew back to Portillo, reporting that he had spotted the plane down. A rescue helicopter headed for the crash site. Frank knew the situation was going to be horrible as he had seen bodies outside the ship. He needed contact with the crew. "Greg . . .this is Coffey. What d'ya got?" Greg came right back and said, "Juan's dead, T.R. and Steve are trapped in the heli. I think my legs are broken. Seth thinks his ribs are broken."

But the rescuers couldn't land at the crash site, located on a 38 degree slope and covered with 2-feet of fresh snow. Frank and Henry, another team member, jumped out of the helicopter and climbed the treacherous slope. T.R. and Steve, realizing Frank was on the scene, yelled for help. Steve was pinned beneath the pilot's seat so was the first and easiest to move. Frank stabilized Steve and moved him into the warmth of the sun's rays.

T.R. relaxes while paragliding into Telluride with a sense of immortality. This bewitching locale held him in rapture and constantly beckoned him "home." (Photos courtesy of Lee Youngstrom.)

He turned his attention to T.R., stabilizing his neck and back, and bandaging his severely lacerated head. A doctor and the director of the Portillo ski school arrived to help. Oxygen was administered to T.R., but he fell unconscious. Two minutes later, he died.

News of T.R.'s death spread rapidly, worldwide. "T.R. died doing what he loved: pursuing adrenaline culture in one of the most astonishing mountain ranges of the world," said Kaia Van Praag, marketing manager of his Telluride studio.

T.R. often said he did not fear death. He considered it the ultimate adventure and would embrace it as he embraced life. When *Powder* magazine asked skiing's best photographers to list the pros and cons of their profession, T.R. responded, "No gripes, life is great."

Monique Cole of *Bike* magazine wrote, "Youngstrom was well loved; his enthusiasm for life was infectious." Eric Wright, of *Transworld*, said of T.R., "He was the coolest guy. . . . My friends and I met T.R. on a snowboarding trip to Wyoming. We came to town, opened the phone book, and picked a photographer. He turned out to be one of the best guys you'd ever want to work with. He went out of his way to make sure we were not only having fun but also getting the job done."

The Youngstrom family arranged a memorial service for August 15, 1997, at Telluride Park, an area over which T.R. had paraglided many times. One friend recalled T.R.'s philosophy: "If things are bad, they'll get better, and if they're good, then let's enjoy them."

"He had tons of friends," says Kaia Van Praag. Some of them, like Tim Abare, Matt Rodosky, Mary Breslin, and Paul Michelotti represented Barrington at T.R.'s funeral in Telluride. They went to be part of the spiritually uplifting celebration of T.R.'s epic life and

works. The family also held two slide shows of T.R.'s life's work at the historic Sheridan Opera House in Telluride. Photographers and friends were asked to share their photos, as well. The day was filled with singing, talking, and sharing "T.R. experiences."

As T.R. lay dying on that Chilean snow-covered mountain top, he said to Frank, "Promise me you'll send home messages to my family and to Isabel, the girl I love. Tell my mother I love her. Tell her I'm going to a better place." T.R. knew it was a place where no one cared whether or not a guy wore tasseled-loafers or a blue blazer.

At least two memorial funds have been set up in T.R.'s honor. Every spring, the art department at Barrington High School selects the photography student it thinks demonstrates the most potential. That student is given a check for $150—not a large sum, but the amount T.R. was paid for his first published photo—enough to set the course of his life. In addition to this fund, a group of T.R.'s friends began collecting money for the creation of a climbing wall at BHS to be used for students during their gym classes and for community members after school hours.

An emotional, energy-charged ceremony took place at BHS on Sunday, April 29, 2001, when the T.R. Youngstrom Memorial High Ropes Course and Climbing Wall was dedicated in his honor. Lee, his mother, said, "It is the embodiment of T.R.'s philosophy—that the greatest risk is to take no risk at all."

T.R. and Lee had an enviable relationship. He traveled the world over but was never too far to call her, sometimes at two in the morning, "just to talk." In one postcard he wrote "Howdy Mom. . .it's Tuesday . . . and I'm still thinking about our traveling. . . haven't figured out where yet. This can't be rushed. Patience. I hope you're happy. I'm sure you are! I am loving life myself, happy, healthy, etc. Couldn't have done it w/out you though . . . so thanks. Love, T.R." (Photo courtesy of Lee Youngstrom.)

X.

Sam Oliver

C harity, volunteer work, and civic assistance will never disappear from the fabric of society. In Barrington, Sam Oliver performs an unbelievable number of activities that reach and touch everybody around her. Sam's grandmother and parents instilled in her the importance and value of helping others.

All throughout her open-space home, Sam has collections that fascinate visitors. A wall of hand-crafted flutes lines one hallway, and colorful, beaded vintage ladies' hand bags fill a bathroom cabinet; madras cloth inlaid with mirrors hangs beside a staircase, while antique typewriters, an heirloom steamer trunk, an 1800s wooden bicycle, handmade sleds, snowshoes, and countless other treasures add personality to the Oliver home. Nearly every collection began from family antiques: clocks, because she acquired her paternal great-grandmother's kitchen clock handed down since 1873, Franklin-style glasses, because her grandfather sold them in his general store, and scores of school and music books, because her mother taught school and loved music. Her cherished childhood surrounds her.

Sam Oliver is a charming woman with liquid blue eyes, soft brown hair, and long, narrow hands. She projects endless buoyant optimism, eagerly shares a hearty laugh, a plate of cookies, and cup of freshly-brewed coffee. When Sam talks about her family, her whole being comes alive. Her eyes glisten, her smile widens, and her tales veer off to experiences she has had with people of other cultures and travels in other countries.

She remembers her childhood in Leon, Iowa, and her grandmother's hedgerow, which lined both side of the driveway with peonies. The flowers attracted a steady stream of visitors on Memorial Day weekends. En route to the local cemetery, many people stopped at Sam's grandmother's and asked to cut some of her fresh flowers to decorate the plots of loved ones. Every visitor left with a generous spring bouquet.

Her parents, Edgar and Delphine Hansell, also demonstrated to their children the importance of giving back to the community. She was born during the Depression, and, as she says, "always surprised and grateful that my parents started a business and family in

Sam Oliver is described as "an agent for change." Seventeen years ago, while helping a dying friend, she recognized the need for a local hospice service, and that's just part of her work on behalf of others.

spite of the times." Sam is the oldest of four Hansell children. Her siblings include Ed, Kathy, and John.

"My father was a hard-working, adventuresome man who owned a Chevy-Buick dealership in Leon and had real estate holdings as well. My mother came from an artistic family, and I grew up in a home where art and music were important. Mother played piano and violin and when I wanted to learn how to play the flute, she drove 140 miles round trip to Des Moines for my lessons and then hurried back to town, so I could attend Girl Scout meetings. Mother believed that if it was the right thing to do, one should make the effort to do it. Now, when I'm asked to play the flute for a wedding or a funeral, I don't hesitate. I play in memory of my mother. I can never forget her willingness to drive all those miles so I could take lessons."

World War II severely affected the citizens of Leon. "We had ration stamp books for flour, sugar, gas, shoes, and uncolored margarine, but we never felt deprived." Just as in many small U.S. towns, the war cut deeply into Leon's population. The doctor, dentist, and many young men were drafted and shipped abroad.

"My infant sister needed emergency surgery when she developed a telescoped bowel. The only doctor available was a retired, 82-year-old physician. My mother almost panicked. But, on the steps of the hospital, she met a former classmate of hers, Dr. Gamet, a physician from a nearby town who was on leave from the army. He agreed to perform the life-saving surgery."

Like many children during war times, Sam was impressionable and suspected her neighbor, Mrs. Fisher, of being a German sympathizer because "she kept the lights on in

Sam Oliver was raised in a loving home. She was surrounded by proud parents, doting grandparents, and the close kinship of her brothers and sister. On the left, Sam sits for the camera when she was four. Below, is the Leon, Iowa, version of "The Spirit of '76." Edgar Hansell plays the bass drum while holding Victory by the leash. Also in the picture are Junior Michaels, a family friend, and Sam on piccolo. "We loved parades," says Sam. (Photos courtesy of Sam Oliver.)

The picture on right is Sam's birthday party. All the children in the neighborhood gathered for the fun. Sam's brother is in the stroller. (Photo courtesy of Sam Oliver.)

her basement all night." Sam thought perhaps the woman was sending Morse code messages to the enemy. She also suspected her second grade teacher of espionage because "she called me up to her desk and asked what news our family had heard from our friend, Dr. Doss. 'Where's he stationed? Where is his company headed next? When will they be moving?'" The teacher's appearance furthered Sam's suspicions. "Her gray hair was pulled straight back in a tight bun; she wore dark-colored clothes and clunky shoes that rattled on the wooden floor as she moved up and down the rows of stationary desks. My imagination ran wild."

Sam was visiting a cousin in nearby Mt. Ayr, on May 8, 1945, when the German army surrendered. She remembers that "spontaneous celebrations broke out all over town and all across America. We felt that night had ended and that morning had come."

When Sam was in her early twenties, her parents both died in separate accidents. They were both only 53 years old. Her father died in a small plane accident and later, her mother was killed in an automobile accident. "Living in a small community like Leon, people rallied to our support. Relatives, neighbors, and friends of my parents came to our rescue. They brought meals, helped with tasks, and gave us advice. My sister, brothers, and I decided to keep our parents' home and knew that they would want us to continue our education. All of us finished college and went on to careers: Ed is a lawyer, Katy a reading specialist, and John an endodontist." Each year, to honor the memory of their parents, the Oliver children provide a Leon High School scholarship for a young man and young woman who exhibit academic and community leadership potential.

Sam attended Graceland College, a 2-year church school where everyone on her mother's side of the family had studied. The motto of the Crescents, the women's

honorary organization at Graceland is, "Count that day as lost whose low descending sun views at thy hand no worthy action done." This became Sam's operative. After finishing at Graceland, she went on to Drake and earned a Bachelor of Science degree with a double major in social science and music, specializing in flute. The degree also certified Sam as an elementary school teacher. All through her years of formal education, Sam nurtured her interests in music, writing, student government, and church. As a teacher, she brought an appreciation of all these areas into the classroom. Following in her mother's footsteps, she taught kindergarten and first grade. "I always enjoyed working with children and taught school until my own children were born."

Sam spent her first year teaching in Minneapolis. "My car was constantly being towed because it couldn't function in the freezing temperatures." She decided to find a warmer place to teach, a place where she could get everywhere by bicycle. She applied to teach in the Territory of Hawaii. Sam was assigned to the U.S. Barber's Point Naval Air Base. During her time in Hawaii, her fascination with travel took hold. Her family had taken numerous trips around the U.S. while the children were growing up, and Sam toured Europe after her junior year in college. In Hawaii, she joined a few colleagues on several low-budget

Sam Oliver and her brother, Dr. John Hansell, take a break during a mission to Honduras in 1977. They accompanied a health team to provide dental and health care to people living in remote mountain areas. "Lights went out at 8 p.m. in order to preserve precious lamp oil. Darkness penetrated everything. But the early morning skies were set ablaze with fires women lighted as they prepared the day's tortillas." (Photo courtesy of Sam Oliver.)

tours around the islands. She remembers "drinking tea for breakfast and retaining the tea bag for dinner" in order to save money for her passion. She and her colleagues traveled from island to island carrying brown bag lunches consisting of peanut butter and jelly sandwiches. One time they rented an old station wagon, referred to by the locals as a "sampan" or "banana boat." It was stripped of windows and siding, providing maximum space to carry bananas from nearby plantations to the seaside harbor. The young travelers also rode on horseback into the heart of a dormant volcano. At the end of the school year, Sam and her friends planned a final trip to the Orient on "Scotch Tape Airlines." They intended to visit Japan, Hong Kong, and Thailand. However, while Sam was en route, her brother called her back to the United States because of her father's sudden death..

She met her future husband, Bob, a navy pilot, in Hawaii, and the couple married on October 18, 1958, in Leon. Their Iowa wedding was planned around the Leon High School, Graceland College, and University of Iowa football schedules. "Community football games are central weekend activities in Iowa. My brother even showed up for our wedding rehearsal in his football uniform, fresh from a game."

After his stint with the Naval Air Force, Bob returned to General Electric and joined their management training program as a metallurgical engineer. During the couple's relocations, their children, Kirby, Lane, Derek, and Chad were born. In 1964, Bob decided he wanted to return to flying and joined the crew of American Airlines. The family settled

Sam and a new friend are dressed in their finest to attend Sunday church. A trip to Haiti found Sam's team charged with building a large cistern to collect water that would be funneled from atop a mountain village church. (Photo courtesy of Sam Oliver.)

in North Barrington, attracted by its proximity to O'Hare, stands of trees, open spaces, and quaint charm. They considered it the perfect environment in which to educate and raise their children.

In 1977, Sam took a trip to Honduras with her brother, John. They accompanied a health team to provide dental and health care to people living in remote mountain areas. "We were overwhelmed by the sights, sounds, and smells when we first ventured into the interior of the country. We ate whatever was available. One morning during prayer service, before breakfast, I was standing near a sack of beans. I heard bugs scurrying around inside. I thought, Oh, no, I hope we aren't going to eat those beans. But the black beans were served to us for supper."

The health team treated patients from dawn until dusk. "We owned one old Army folding dental chair which we carried up the mountain slopes. When we arrived, we always found a long line of waiting patients. The people knew we were coming and wanted to be treated before we left for another village. We made lots of popcorn and lemon grass tea to feed people who traveled miles on foot for health care and who came without food.

A local young man who wanted to become a dentist assisted my brother, so I found myself caring for children whose parents were ill. The team gave the children their first tooth brushes, and they would brush their teeth nonstop for 20 minutes. The children's parents begged us for slivers of handsoap or small quantities of shampoo—luxuries to them."

She also spent the time typing a series of health guidelines, which she hoped would inform residents of the importance of basic rules of hygiene including frequent washing of hands, not drinking the water in which their animals bathed, and cooking meals with cistern, not river, water.

A second trip in 1979 landed Sam in Mexico. This time, the goal was to rebuild an old, unsafe, adobe church. "I remember my body being covered with dust. It was the dry season and the land was completely parched. Any gust of wind sent the topsoil floating everywhere. The blinding dust made our task all the harder, but we managed to reconstruct the church while we were there."

A trip to Haiti found Sam's team charged with building a large cistern to collect water that would be funneled from atop a mountain village church. "Haitian groundwater is polluted, and villagers walked miles down the mountain to get water. Two weeks after we arrived, provisions for a safe water system stood in place." Then the team set about teaching the people to use the cistern water, rather than ground water.

Sam believes these trips have been life-altering for her and for her family. For example: her son Chad accompanied Sam on a trip to the Dominican Republic. "It was down-right scary. We arrived in a tiny village where armed guards were stationed atop the building where we slept. We heard gunfire, and a riot broke out. After two days of living in the village without electricity, indoor plumbing, or running water, Chad asked, 'Do volunteers really last here a week?' 'Yes,' Sam answered, 'and we're staying two.'"

The people in this village were using a nearby river as a latrine, a bath, and a laundry. "You can imagine our hesitation to accept even a cup of tea. I am always taken aback by people who have so little, yet have so much to teach. They walk miles in pouring rain to attend chapel services. They shower attention on their children and are so grateful to anyone who makes their lives more tolerable. I learn more from them than they learn from me," said Sam.

Each trip she takes ends with admirable results. For instance, in Honduras, a new clinic has been built in the mountains since the health team first traveled there. "We also sent

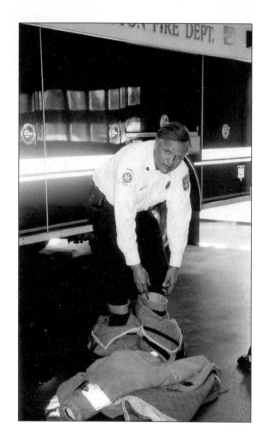 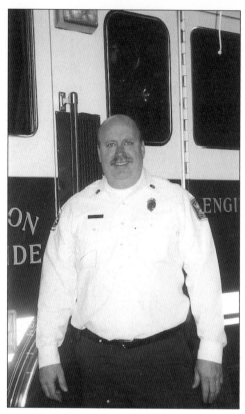

Pictured on the left is Lt. Lenn Grant and on the right is Deputy Chief John Feit.

The Fire Department has a long history in Barrington. Several large fires caused its citizens to see the need for better and greater water supplies and a more proactive fire department. On December 22, 1897, the village board passed an ordinance to create a water works system which could be used to protect Barringtonians when fires broke out anywhere. According to Arnett C. Lines in his book, History of Barrington, Illinois, *"A fire department was organized on June 15, 1898, with 37 volunteers. Every man was assigned duties, and regular meetings, practices, and roll calls were held with faithful attendance required. For some time, each man was paid 25¢ for attending each meeting, and they soon began paying each man $2 for labor at a fire. The Secretary was paid $5 a year. Oyster suppers and many ball games were put on for fun as well as to meet expenses. Firemen were sent to State Fire Conventions. In the beginning, there were two hose teams within the company as well as a hook and ladder company, but the hose teams were soon united. This organization joined the State Fire Association in 1900, and that association made frequent requests of the Village Board to pass certain helpful and protective ordinances. It got the Board to pass a 2% tax on fire insurance premiums in Barrington. The first fire fighting equipment was a 2-wheeled, hand-drawn, hose cart that was still in usable condition at the time of the department's semi-centennial. Later came the Ford truck bought in November, 1919.*

On Tuesday, February 6, 2001, Sam Oliver is honored at the annual luncheon. Here she holds her plaque commemorating her dedication to saving lives through CPR training throughout the Barrington area, and to campaigning and fund raising to install defibrillators in local police cars to be used as needed at accident scenes. On the left is Barrington-Inverness Police Chief Jeff Lawler; to Sam's right is the Master of Ceremonies, Darrian Chapman, of NBC 5, Chicago, and Ron Hamelberg, former Mayor of the village. (Photo courtesy of Sam Oliver.)

motorbikes to Ed Guy, a friend from college who ran a clinic. Before the motor bikes arrived, Ed depended on getting around by thumbing for rides from occasional truck drivers traveling along the dirt roads. In Haiti, we brought treadle sewing machines, which the women in the mountain villages use. They came one day a week to the village school where the sewing machines were kept and made clothing for their families. They also sewed other items to sell in the markets. These women seemed so content. All the while they worked, the women sang and talked," said Sam.

But Sam Oliver is more than a missionary abroad: Barrington residents consider her name synonymous with energy, dedication, and service to her community. She currently volunteers with many organizations. Her work for the North Cook County Division of the Heart Association of Metropolitan Chicago began in 1977, when she was asked to establish a CPR training program in the Barrington area. She and her friend Penny Horne launched an enormous project of training one of every four area residents to provide CPR. "I feel a great sense of satisfaction when I see how widespread knowledge of CPR is today. All

Barrington High School sophomores are trained in CPR, as are teachers, policemen, firemen, and all kinds of individuals. And everyone who makes a 'save' is grateful for the training."

Sam became the first woman to chair The American Heart Association of Metropolitan Chicago and was honored for her efforts to place Automated External Defibrillators (AEDs) in Barrington's eight squad cars. Village officials provided funds for four defibrillators, and Good Shepherd Hospital funded four more. Heart-related deaths have been a concern to Sam for more than 20 years. Two of her grandparents suffered strokes. "My grandfather was forever unable to speak after one attack. I'm sure his presence in our home had a profound effect on me." She is committed to collecting funds for heart and stroke research so others can avoid the pain she experienced watching her grandparents deal with the disabilities brought on by strokes.

In 1977, the Barrington Area Development Council (BADC) presented Sam with its distinguished citizen award. Arthur Rice Jr., president of BADC at the time, said, "She is an individual who has provided outstanding and unusual service to the community. She is an excellent selection for this award. Whether it's been her work for BADC, the Girl Scouts, the American Field Service at Barrington High School, chair of the Barrington Bicentennial Commission beautification committee, or with the CPR training, Sam Oliver is always there."

Sam's work with Hospice started in 1982, when a woman whose husband was dying of cancer called her. Unable to leave her husband, the woman told Sam she needed someone willing to attend one of the first hospice meetings in the area in Lake Zurich. Sam agreed to go. A local physician and psychologist talked about hospice's then little-known service of helping dying patients and their families. They likened the new concept to the Middle Ages hospice practice of providing weary travelers with a place to rest before they journeyed farther.

Sam was intrigued with the idea and agreed to work with others to organize a local hospice. It was then that Hospice of Northeastern Illinois (NHI) was established. Today, NHI provides care for people who are terminally ill. The team includes the patients' own physicians, nurses, certified nursing aides, social workers, chaplains, grief counselors, and other trained volunteers. The goal is to ease the suffering of patients by offering emotional, spiritual, and physical comfort. Sam has served the group in various capacities, most notably as a fund raiser and as its president.

She has had personal experience with two recent untimely deaths and has seen first-hand the role hospice can play during the time leading to death. Her sister-in-law died in her early forties of breast cancer and a nephew in his thirties died of a brain tumor. In the case of her sister-in-law, hospice care was not sought. But in the case of Sam's nephew, the young husband and father chose hospice when he knew the medical community could no longer offer him a cure. He died at home comforted by his family and friends.

One of Sam Oliver's paying jobs is serving as Staff Director for Citizens for Conservation. She took on the job when the organization had numerous members taking minutes and writing memos at meetings and then taking records home to be boxed and stored in closets. This eclectic filing system needed to be organized. "Someone had to keep track of all the information and have it available in a central location. Someone also had to be able to find data at a moment's notice, so I agreed to serve as CFC's director," said Sam.

Over the course of its history, Citizens for Conservation has helped preserve over 2,000 acres in the Barrington area and currently owns over 343 acres. Some of the properties have been donated to CFC and others have been purchased outright in order to save them.

Sam Oliver was elected Chairman of the American Heart Association of Metropolitan Chicago. Here she addresses an audience of Heart Association experts and reminds them of the need to pressure communities to adopt a CPR training policy and to encourage them to demand defibrillators in police cars to enable officers to assist accident victims with these live-saving devices. (Photo courtesy of Sam Oliver.)

The lands the organization preserves and restores include a variety of ecosystems: a fen, a bog, sedge meadows, prairies, wetlands, and savannahs. The importance of preserving these areas is immeasurable. For example, Sam said, "The endangered Baltimore Checkerspot butterfly, which depends on the turtlehead plant for its livelihood, is one of the species that thrives in the Wagner Fen in Tower Lakes, and we're fortunate to have that area under our stewardship."

Building and population expansion in the area also threatens native birds, plants, and wildlife. Citizens for Conservation is dedicated to "Saving Living Space for Living Things." On February 6, 2001, at the Barrington Area Library, CFC celebrated its 30th anniversary. At that time, CFC proudly announced that the organization had acquired an additional 65 acres. "Acquisition of this land greatly expands the Flint Creek Savanna preserve, which recently became the site of CFC headquarters," said Sam.

Of all the awards Sam Oliver has garnered over the years, she says she is proudest of the one she received on October 7, 1999, the Presidential Daily Point of Light Award. Sam was chosen for her work to help bring hospice to the Barrington area; for being co-chair of its annual fund raising drive; for serving as a camp counselor at Camp Courage, a bereavement camp for children who have lost a parent, sibling, or other loved one; for her dedication to the goals of CFC; for her work with the Chicago Metropolitan Heart Association; and for her volunteer mission trips to developing nations and depressed area

CITIZENS
FOR
CONSERVATION

CFC's ultimate goal is the "planting, seeding, and maintenance of areas under its stewardship in order to create a livable habitat for songbirds, marsh birds, and waterfowl as well as a host of other creatures that can thrive only in the quiet refuge of prairies, wetlands, and oak woods."

Sam stands amid a natural savannah at Flint Creek. The area has been made secure by the Citizens for Conservation. (Photo courtesy of Sam Oliver.)

s of the U.S.

"We need heroes to emulate, and Sam is truly a hero," stated Jeanne Hanson, past president of the Volunteer Center of Greater Barrington. "Her slight stature, her quiet way, her unassuming volunteerism give us hope that we, too, can take on the role of community-building-world-betterment."

"In thinking about the ways my paternal grandmother and mother went about with calm resolve, affecting change, and contributing to their community," Sam said, "I think of the words on a sailing t-shirt that was given to me. On the front is the simple outline of a tall sailboat catching the wind and the word, 'Womanship.' On the back are the words, 'nobody yells.' I laugh when I think of Mark Twain's quote, 'Few things are harder to put up with than the annoyances of a good example.' These two women were good examples, and I'm grateful."